12
PHOTOGRAPHIC JOURNEYS

Iran
in the 21st Century

Curators :
Anahita Ghabaian
Minou Saberi

Silk Road Gallery - Tehran

12

PHOTOGRAPHIC JOURNEYS

IRAN
IN THE 21ST CENTURY

Curators :
Anahita Ghabaian
Minou Saberi

Art director :
Farshid Mesghali

Design and Layout :
Ali Bakhshi

Silk Road Gallery - Tehran
info@silkroadphoto.com

2003

Sponsors :
Ahmad Ghabaian
Abbas Gharib

C O N T E N T S

INTRODUCTION

This exhibition presents twelve photographic voyages through Iran in the twenty-first century. The ten participating photographers have each chosen a different aspect of daily life in their country: a cafe, a bus trip, a shopping center, a "living martyr", the clerics etc. This kaleidoscopic vision of Iran takes the viewer to the very heart of the variety and contradictions of a people among whom nothing seems to be in its place. A mosaic of contrasts appears in behavior and attitudes, juxtaposing a world at the same time modern and archaic.

Themes in the work of certain of our photographers overlap; others lay stress on a particular aspect of life. But one theme runs through them all: the woman. She is everywhere. The Iranian woman perhaps exists, perhaps unconsciously, at every level. While under the rule of the 'hijab', she still appears in the streets, in the shopping malls and cafes with her make-up and her scarf lightly slipping from her head. She tests the limit of the 'hijab' and emerges from the images to be like young women everywhere in the world.

Mehraneh Atashi illustrates events in a cafe in Tehran. These photos show another face of the 'clandestine life' of Iranians. The cafes are places where the opposite sexes meet, faces pressed against faces, talking in open intimacy, smoking cigarettes, in a warm atmosphere against lowlights and the flames of candles. Had it not been for the cover badly hanging from the head, one could be anywhere as the gestures, glances and attitudes reflect the sensibilities of today's youth.

For Hana Darabi photography is, above all, a sort of nostalgia, perhaps a melancholy
arising from an internal self-exile. Her efforts focus on showing fragmentation of time and space. Her scenes from the daily life of

a family all evoke the same disjointed movements of hands, heads and looks of people isolated in a room walled by silence. The images are dismembered: a head cut, another emerging from under the robe of a woman, two men on a couch separated by an irreversible fracture of time. At times they are reflections in a mirror or an intimation of a smile which hides boredom. All these human beings appear frozen in time, like statues awaiting an event that never comes.

Bahman Jalali is the most accomplished and experienced of the ten exhibitors. He concentrates wholly on one theme: 'Steps'. Steps go up or down depending on the event he wants to capture. Two colors dominate: yellow and black. Yellow can be a taxi, a bag, a case, a bicycle. Black is women in '*tchadors*' or men walking up or down steps. The yellow remains fixed as the world around it changes. It organizes the events, is a reference point, a magnetic field around which all compositions become possible: movements down, movements up, until the summit is reached. Perhaps life is, after all, nothing but a passage, a continuous going and coming without aim, without end; it revolves around an axis which is everywhere, and a circumference that is nowhere. Or life could be, as Omar Khayyam saw it, an absurd repetition of cycles which comes back ceaselessly, in the same manner, for all eternity.

Farzaneh Khademian takes us inside the bus. There sexual segregation is brought out. Images, for the most part, show isolated women. They reflect an old lassitude, a mental fatigue. One is sleeping; another is sunk in herself with a lost gaze. The body language speaks of a void inside, of exhaustion with life, of failure and upheaval, of people crushed under social constraints. There is no ray of hope to add sparkle to these haggard looks, of lives condemned to a fastidious repetition.

Arshia Kiani presents a plastic representation of scenes from 'Ashoura' ceremonies. These are collective acts of mourning which have the mystical dimension of Redemption: men, semi-naked, are absorbed in sorrow, beating themselves, lost in ecstasy. A handsome young man with a hand on his heart, his gaze searching out the miraculous beyond, suggests a Renaissance painting.

Abbas Kowsari addresses the body-builders. They overwhelm us with their overblown and rocky muscles. They generously show us the physical prowess of their well oiled bodies. And there are the viewers who devour their heroes and demi-gods with their eager eyes, almost with envy. The body builders do not aggress, but seem to caress, seduce and invite the viewer with their theatrical poses, at times skilled and at times gauche. Here, as in other themes presented, the tensions of different modes of existence are presented, whether in a shopping mall, a bus, or on the body builder's stage. Abbas Kowsari has a second theme, the *'flaneuses'*: photos of young girls in jeans, apparently lazy, girls who walk up and down the streets, come out of a car, mobile in hand, and sometimes lean, aimlessly, against the front of a car. We do not know what they do or what they want. They are, in short, real *'flaneuses'*.

Yalda Moaieri shows the bustling life of a shopping mall in Tehran. Her photos reveal the reverse side of Islamic society. Here the youth, broken free, rebel against conventions and exhibit their 'Western' preferences. Girls, carefree and made up, and boys in tight tee-shirts and Keanu Reeves glasses, showing their muscles, pass furtive glances, fix dates: here is the youth advertising its own ways of modern life.

Javad Montazeri concentrates on the behavior of the clerics. In his photographs we see turbaned heads in most unlikely places: reflected in surrounding glasses, meditating on a grey rug with green lines, riding a motorcycle, behind computers. Times seem to cross each other, or one encases the other, creating surprises, sometimes burlesque and absurd, but always fascinating.

Omid Salehi relates the story of a 'living martyr', paralyzed and in a coma. The photographs begin like a screenplay with an empty wheelchair and end with the weeping eyes of a man reduced apparently to a vegetable life. In between one sees his parents affectionately around him, caring for him, washing him, combing his hair, like a child in a cradle. Salehi then takes on the billboards and paintings which cover the walls of the capital and tell conflicting stories. One of them shows an Islamic militant, who, almost angry, shouts slogans while women in 'chadors' indifferently do their shopping. In other photos there are women who move like shadows, black crows lost on a carpet and red arcades.

Hamideh Zolfaghari, like Arshia Kiani, focuses on 'Ashoura', bringing out the mass movement, green flags, and the rhythm in the flux of motions remembering the martyrdom of Imam Hussein. For this photographer, the image is far more eloquent than words. 'An image conveys more emotion than a thousand words', says she.

WALLS

Omid Salehi
Javad Montazeri

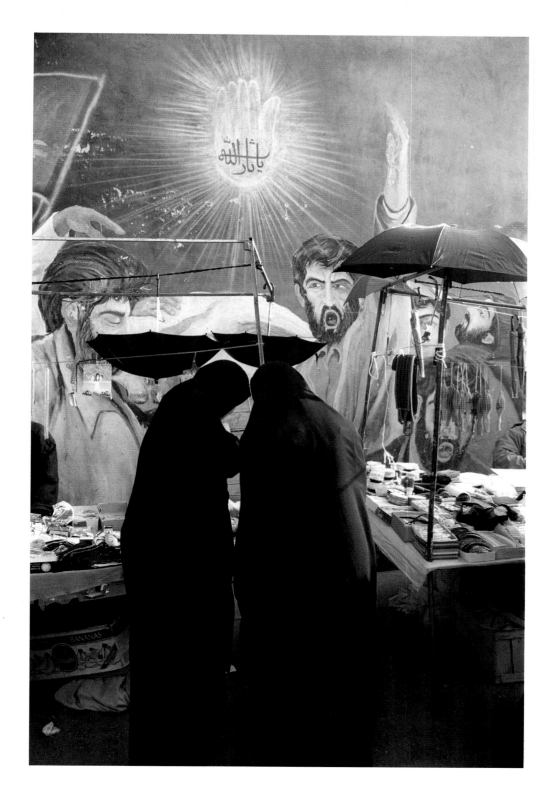

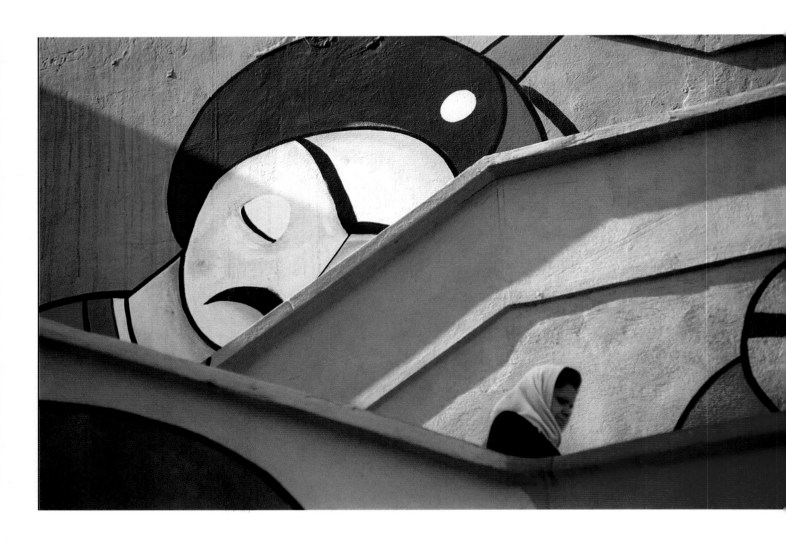

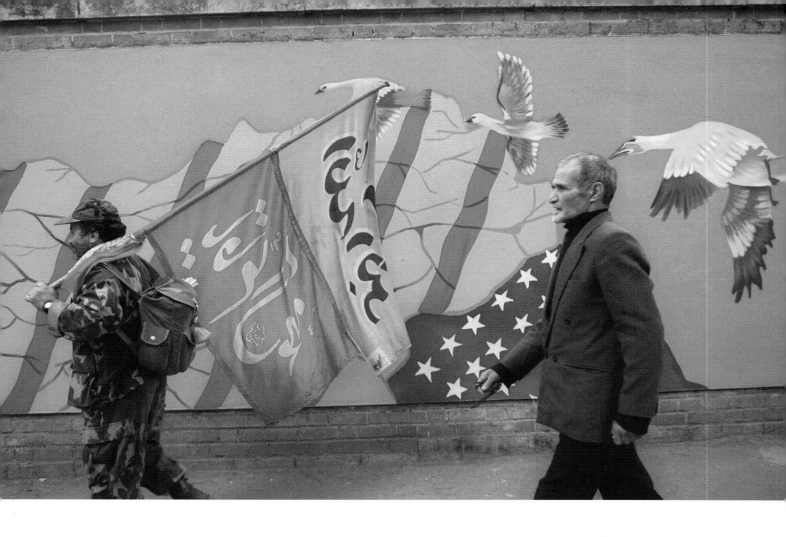

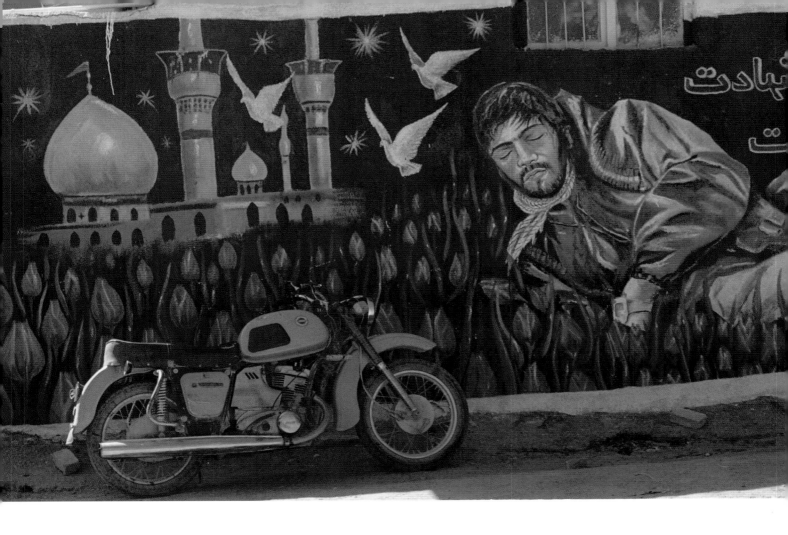

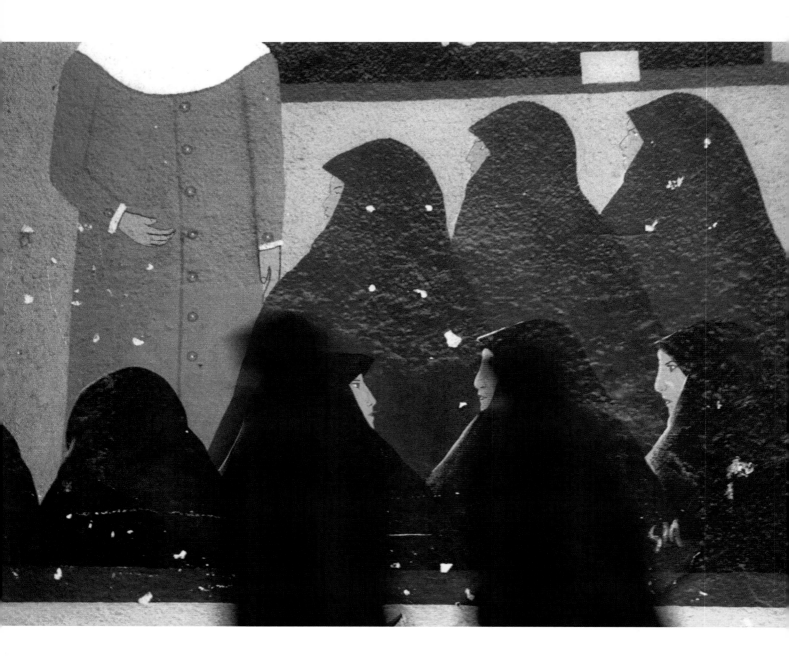

EVERYDAY LIFE NOTES

Hana Darabi

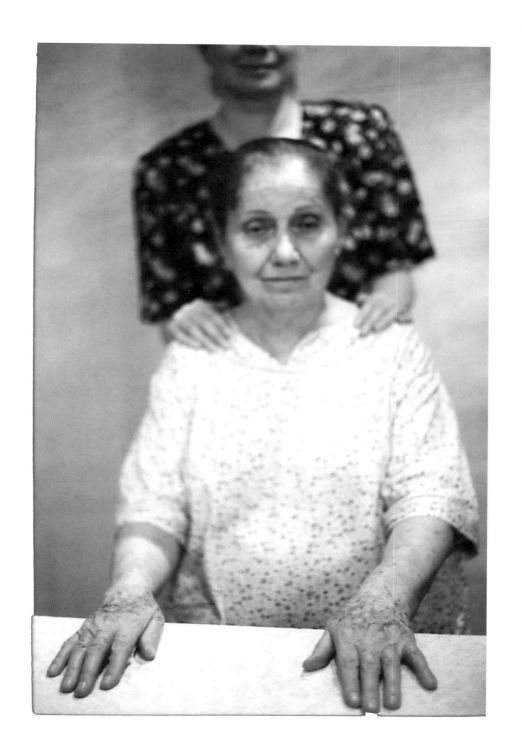

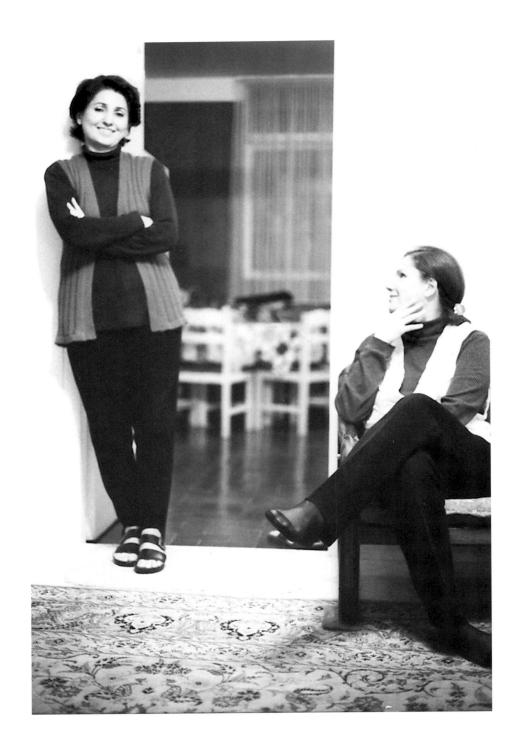

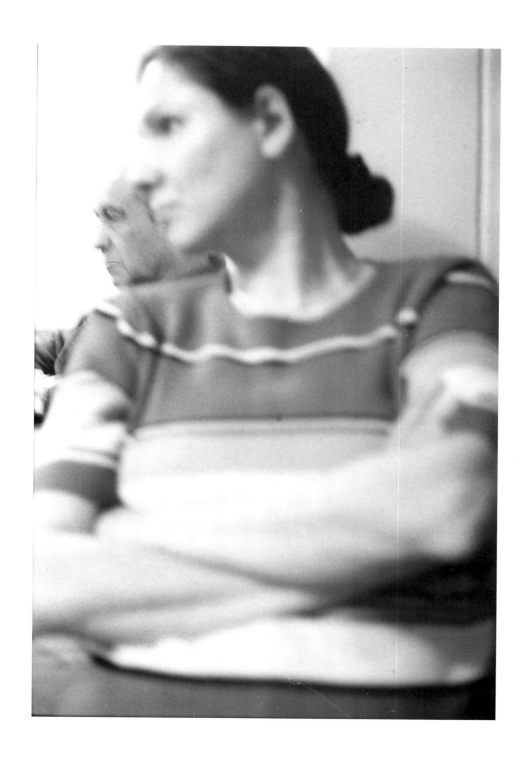

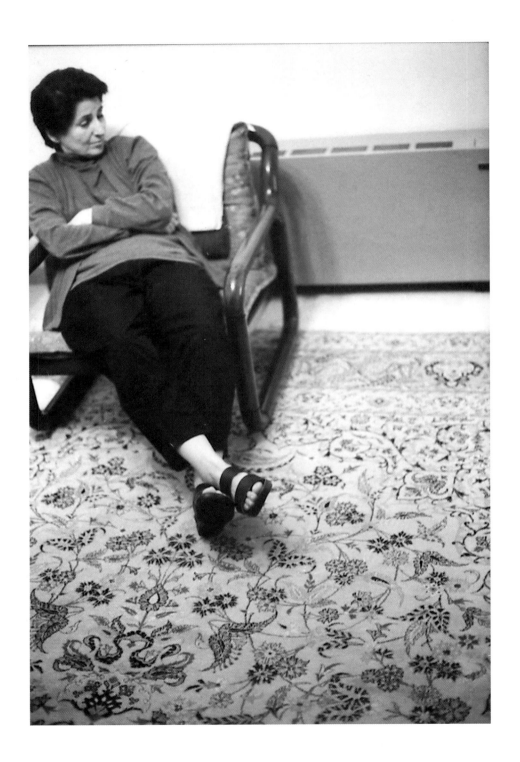

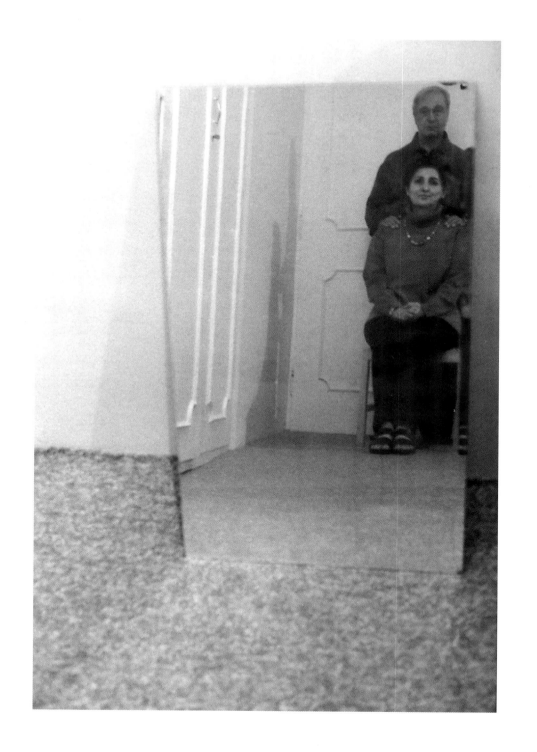

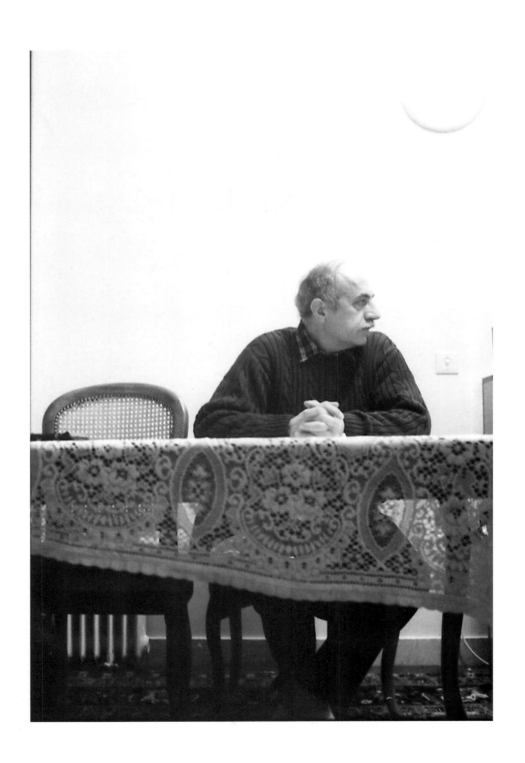

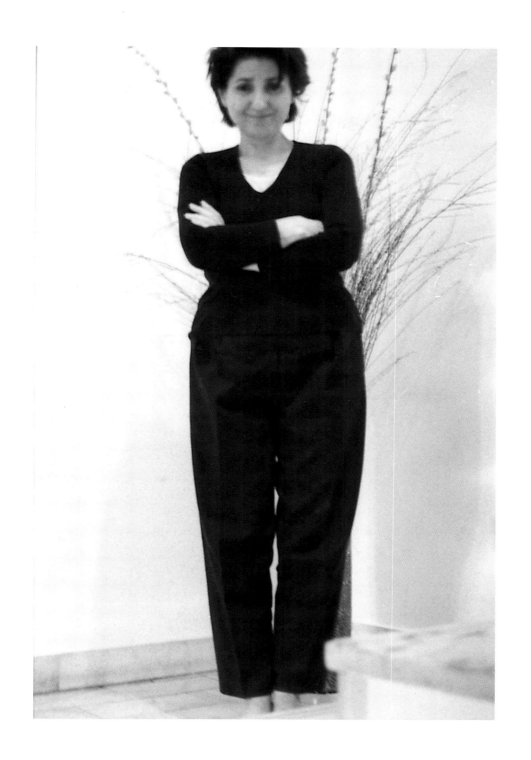

Hana
Darabi

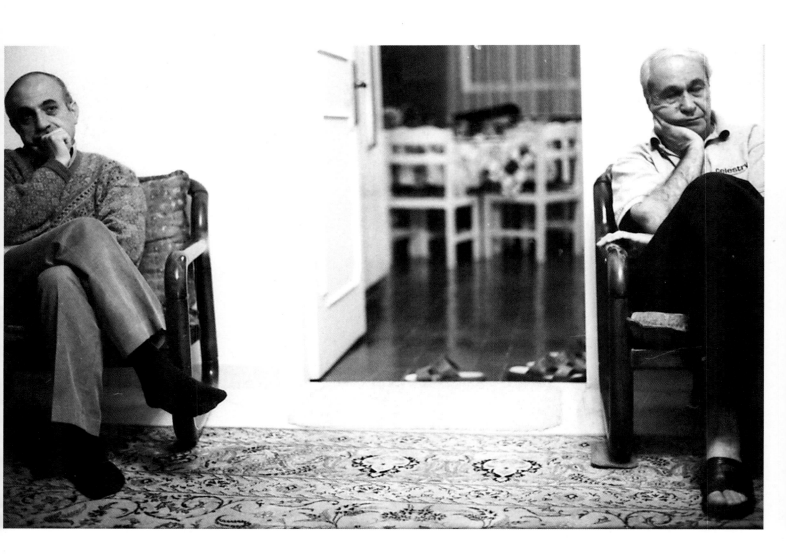

Hana
Darabi

24

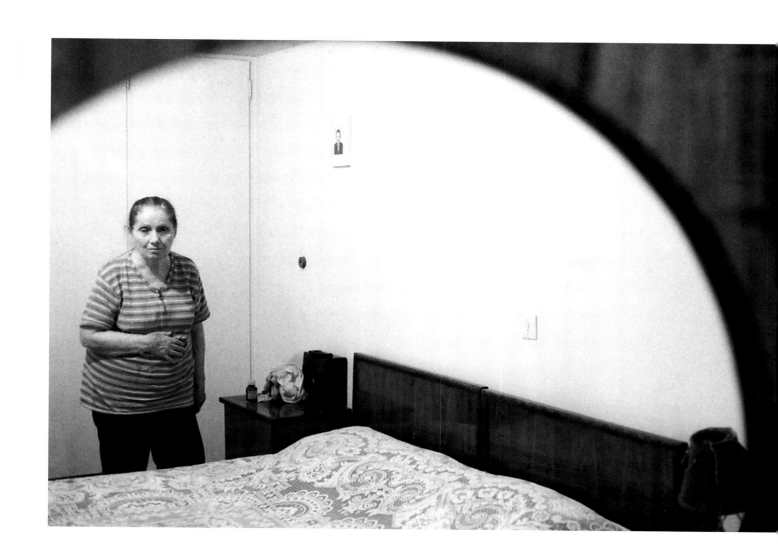

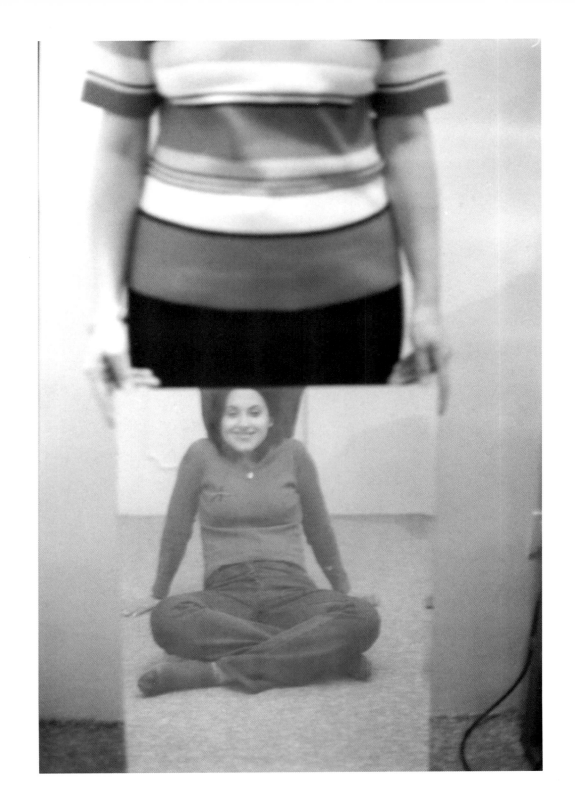

ASHOURA

Arshia Kiani
Hamideh Zolfaghari

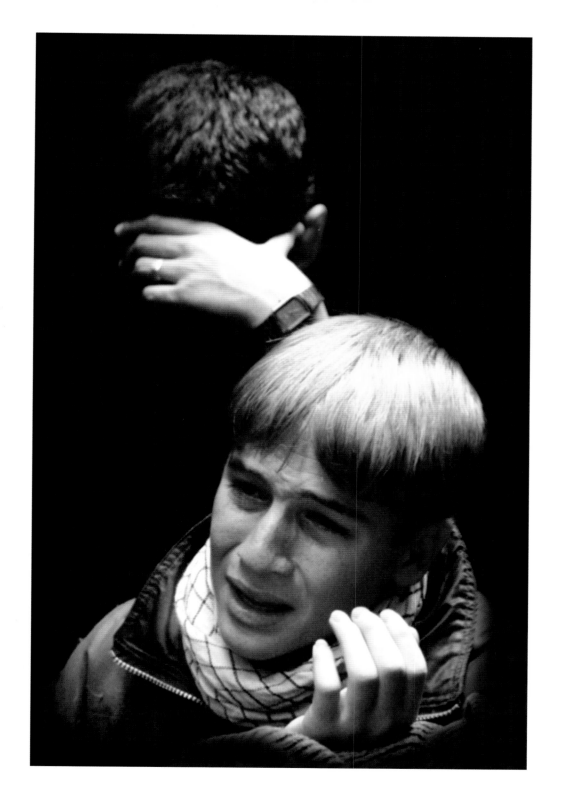

Arshia
Kiani

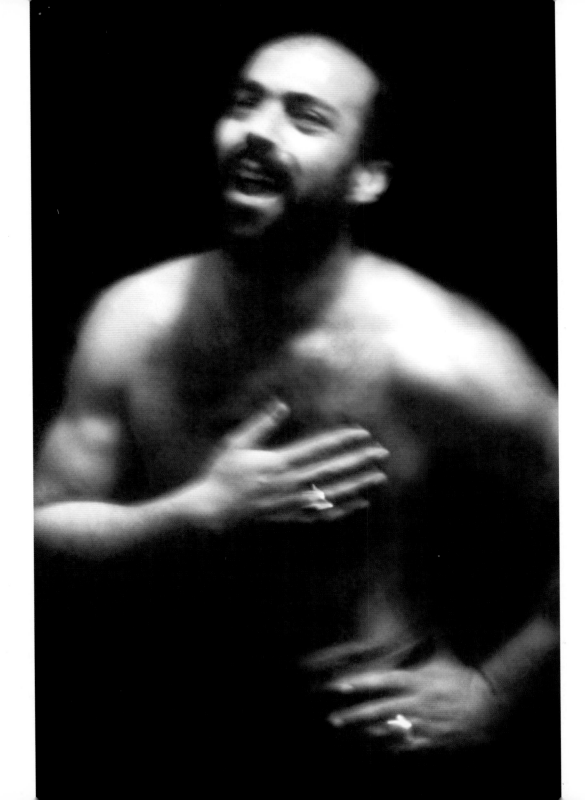

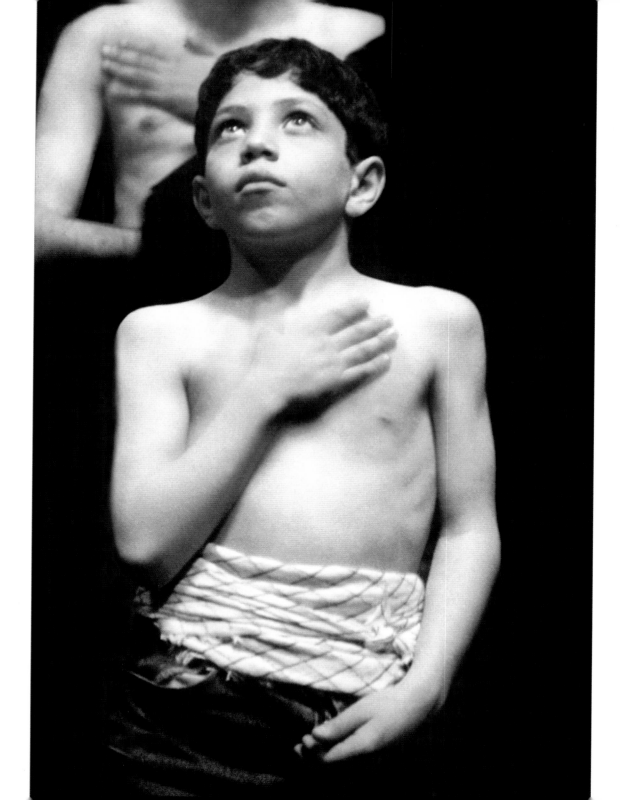

Arshia
Kiani

31

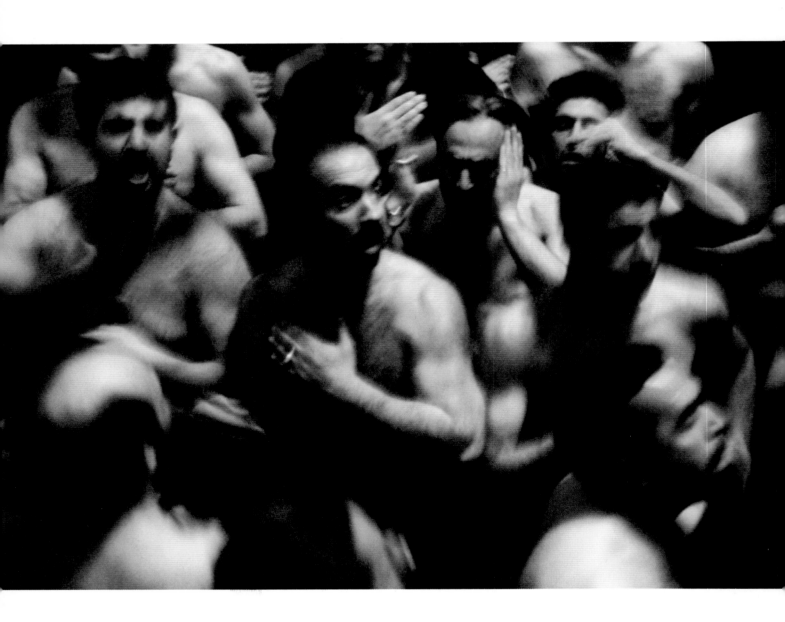

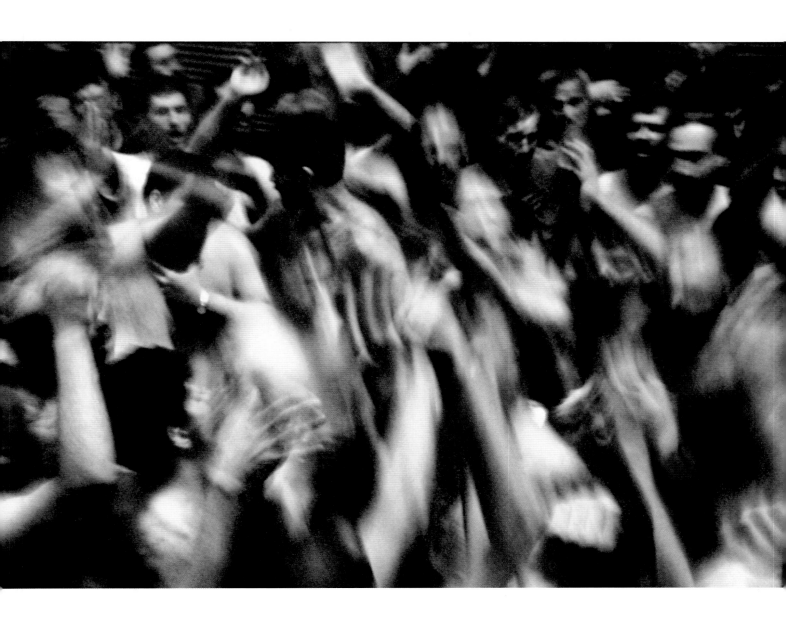

Arshia
Kiani

33

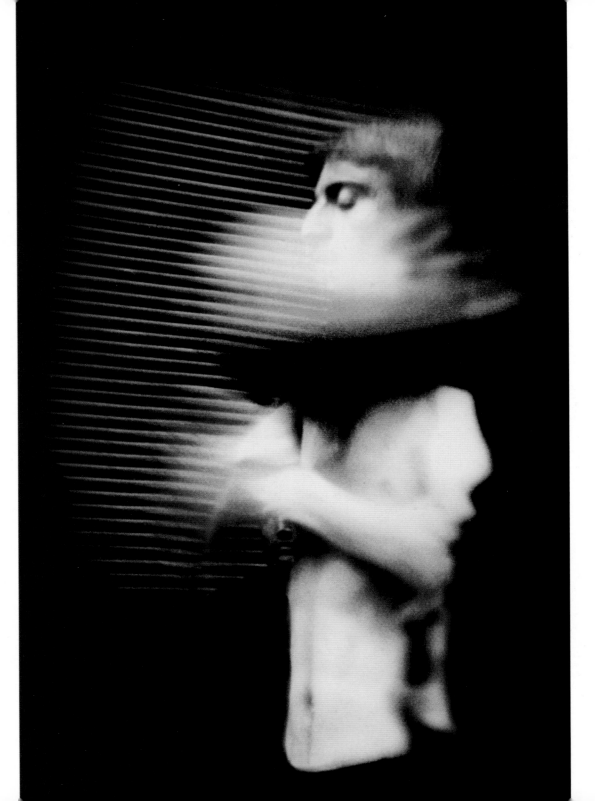

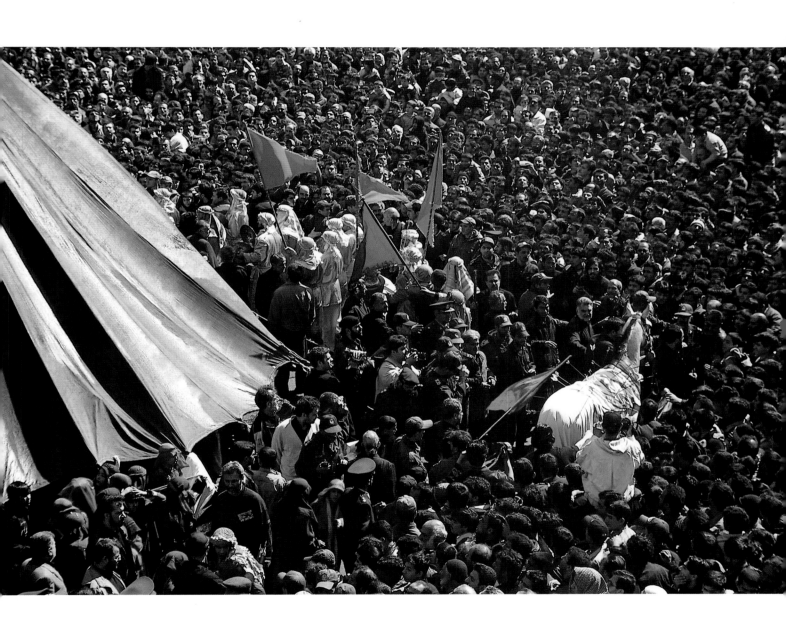

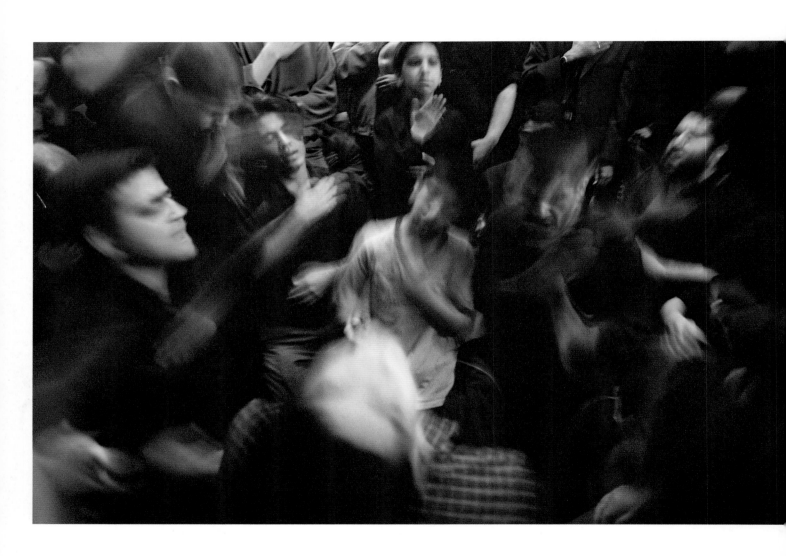

Hamideh
Zolfaghari

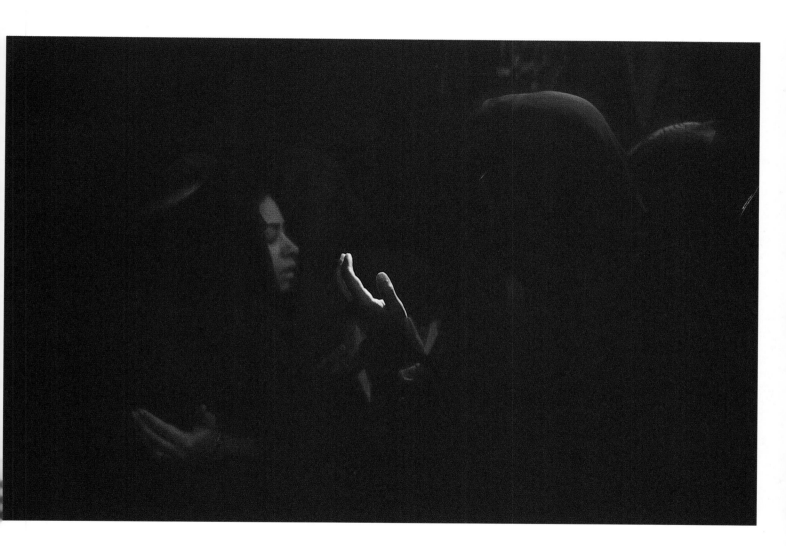

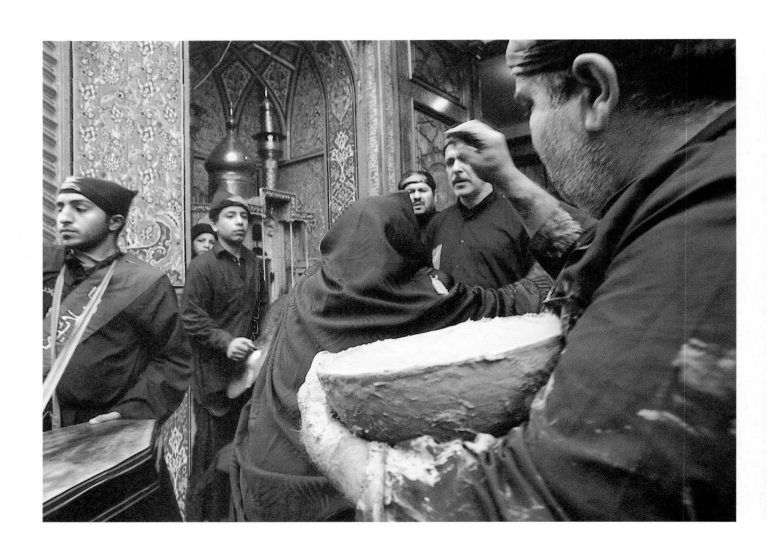

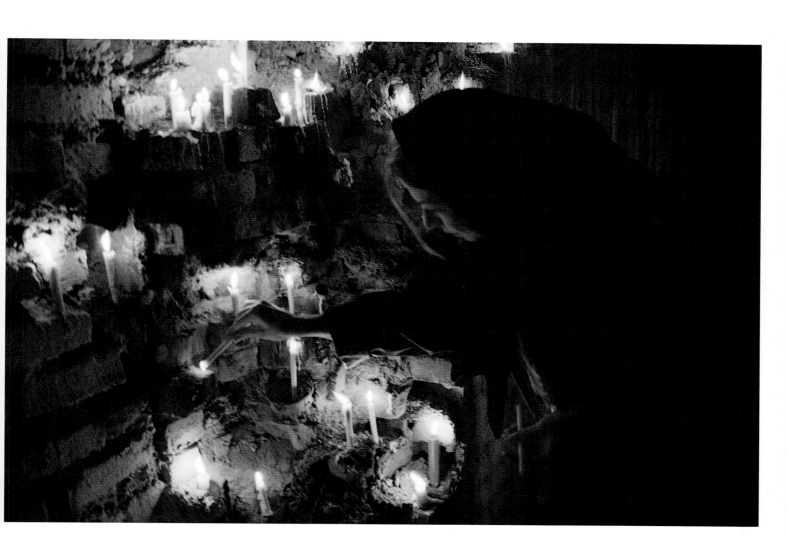

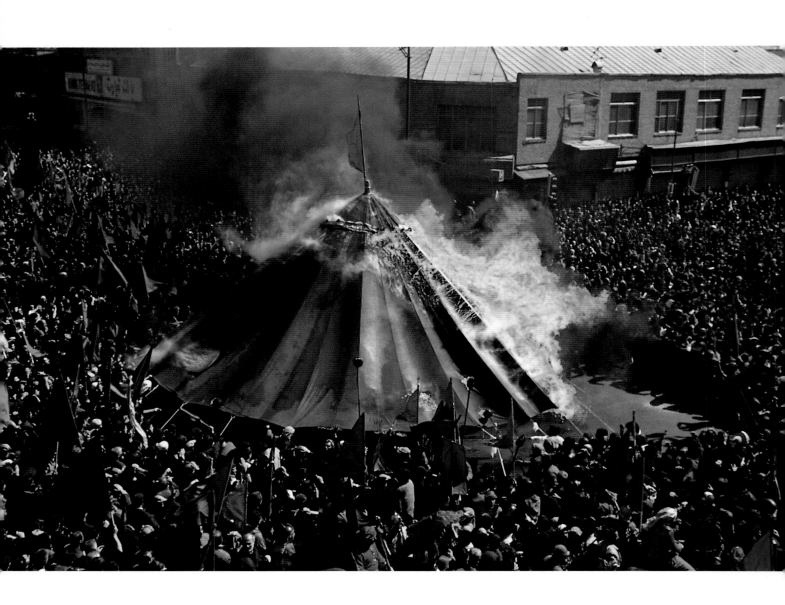

Hamideh
Zolfaghari

40

BODY BUILDING

Abbas Kowsari

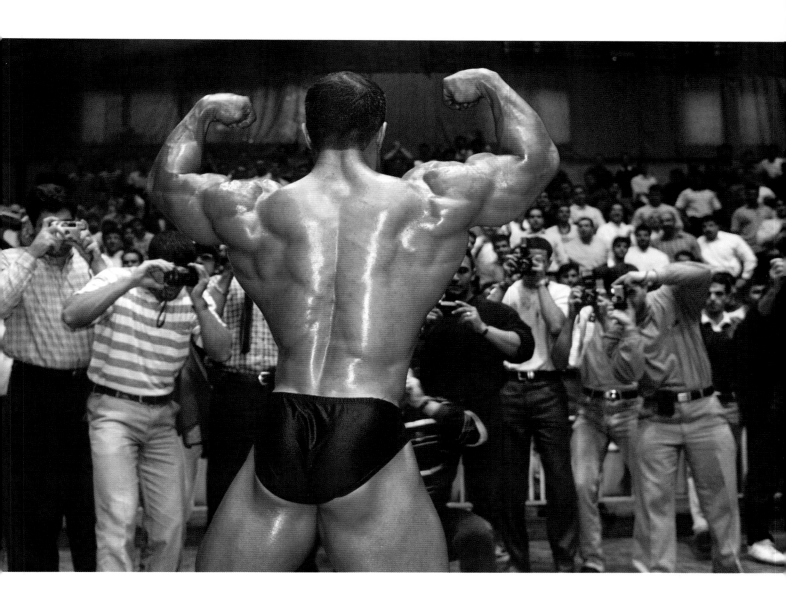

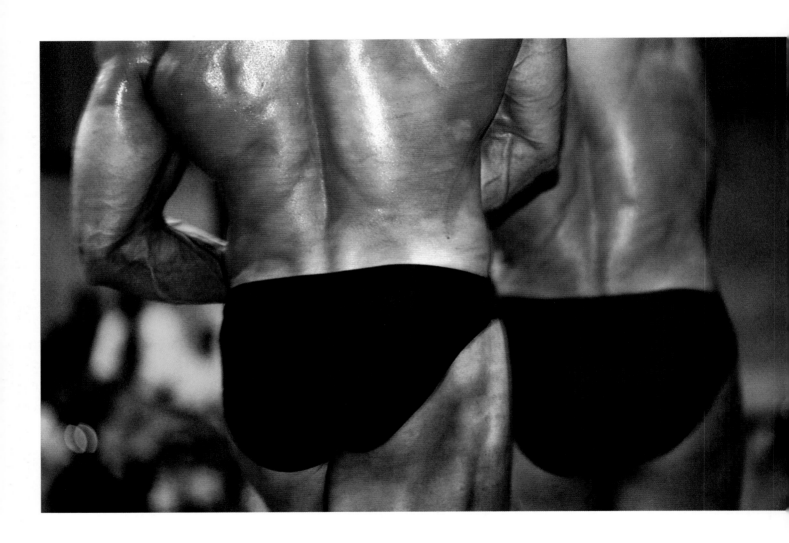

Abbas
Kowsari

44

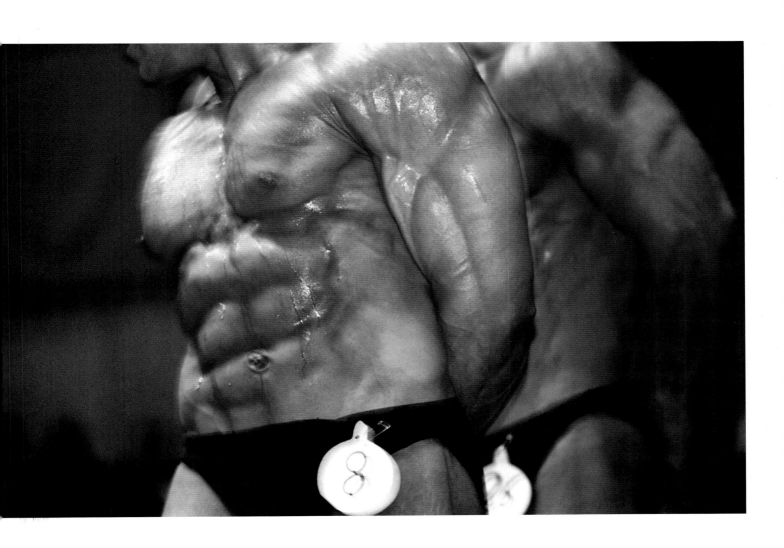

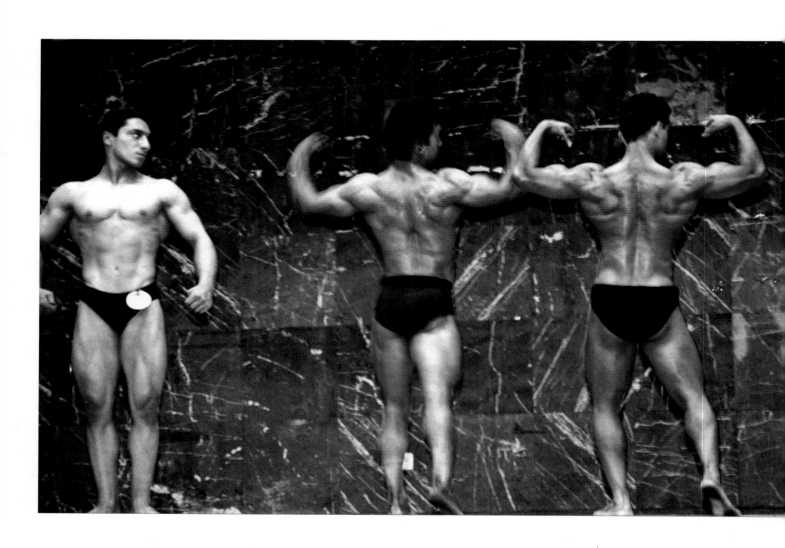

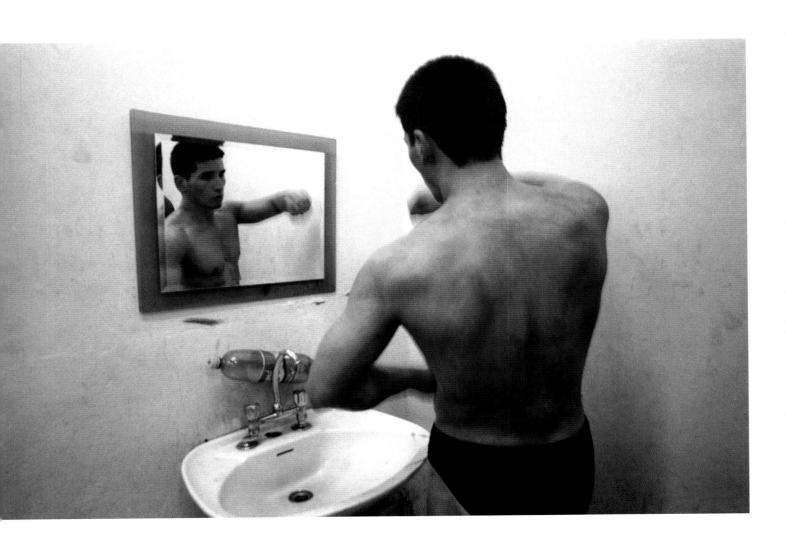

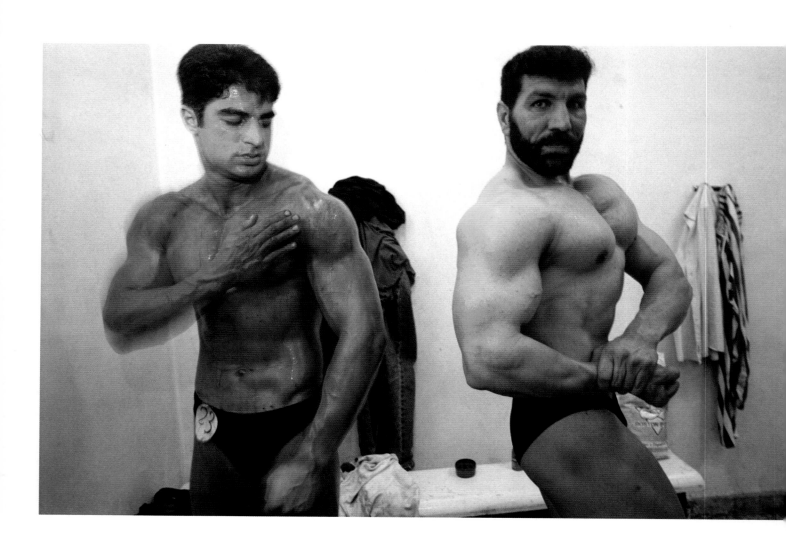

Abbas
Kowsari

48

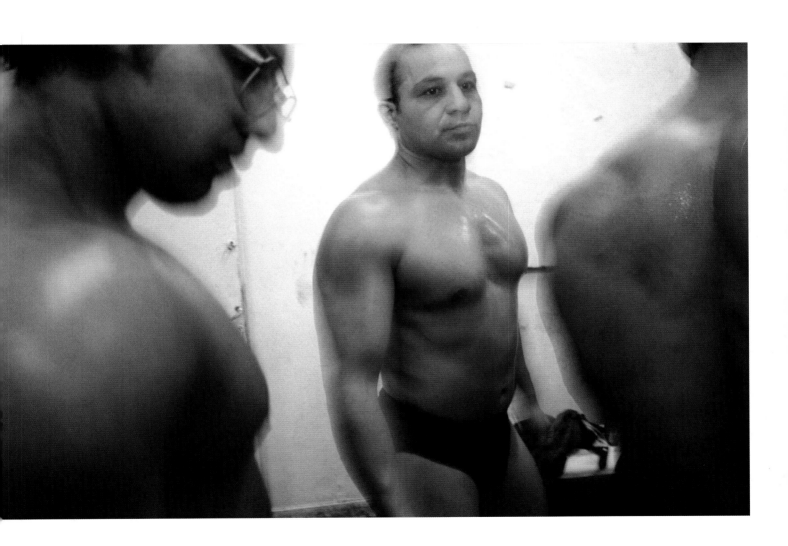

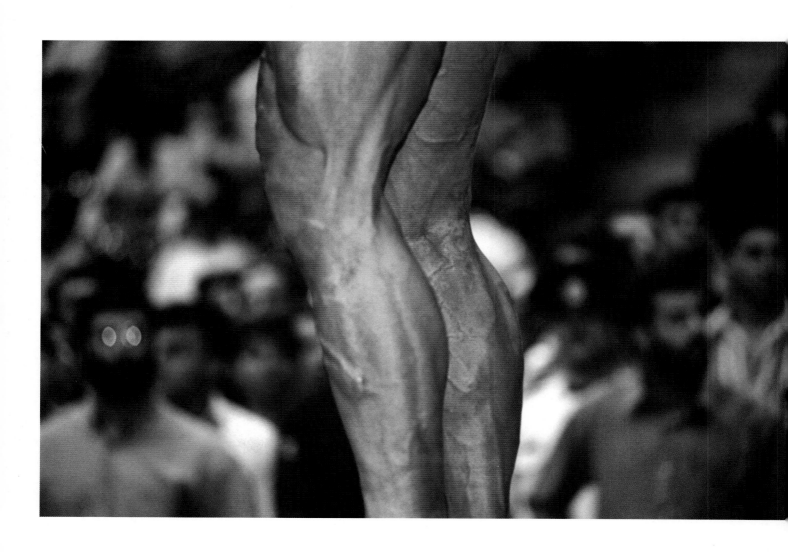

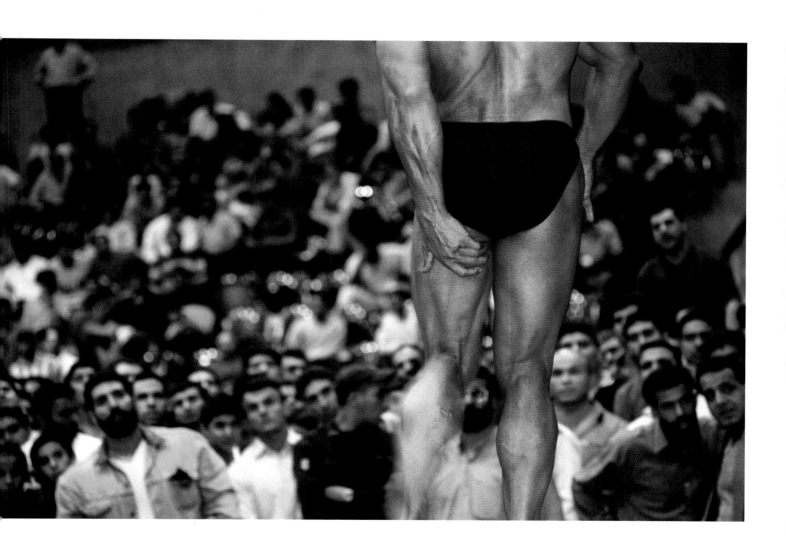

Abbas
Kowsari

51

CLERICS

Javad Montazeri

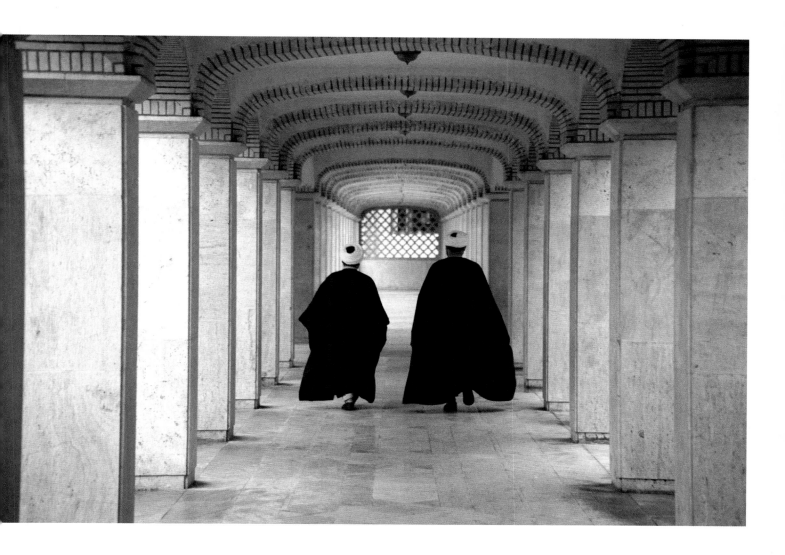

Javad
Montazeri

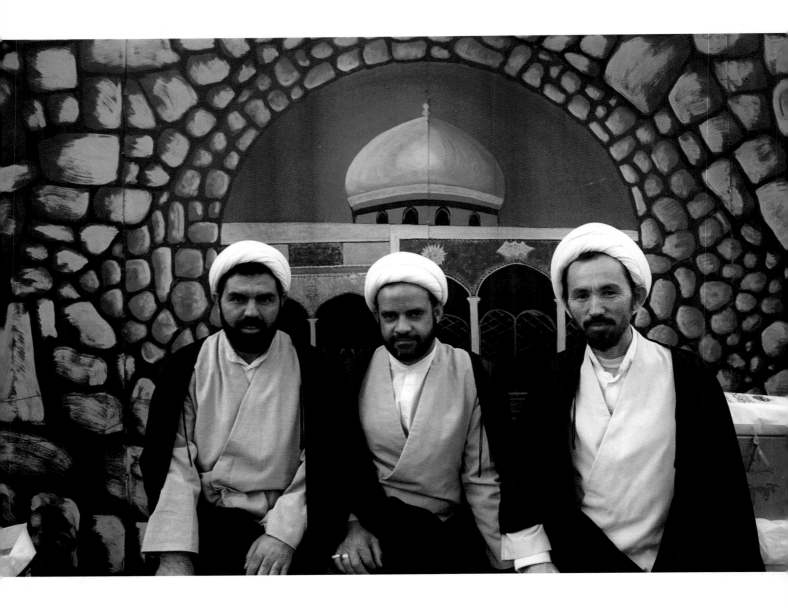

Javad
Montazeri

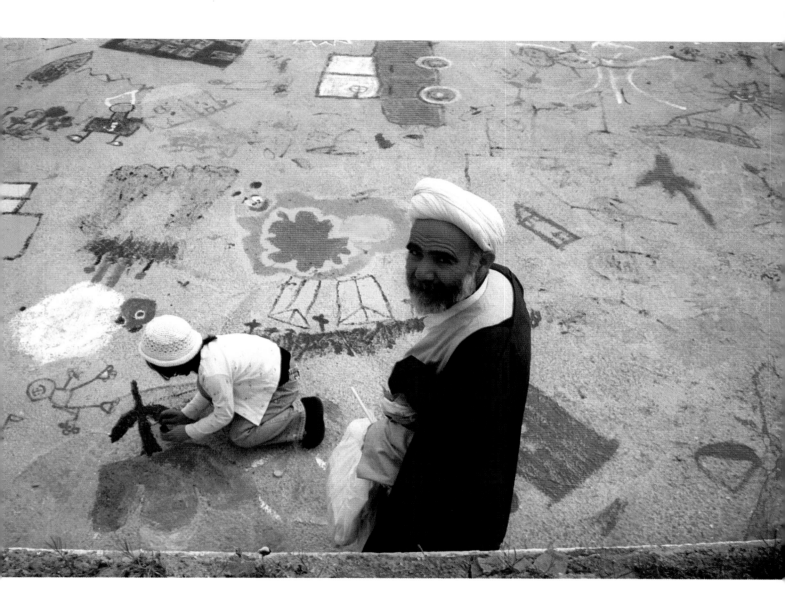

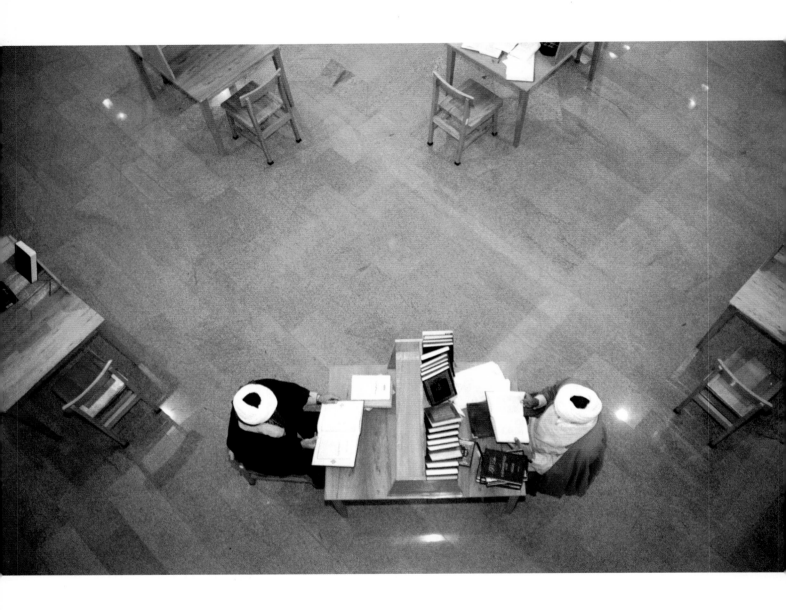

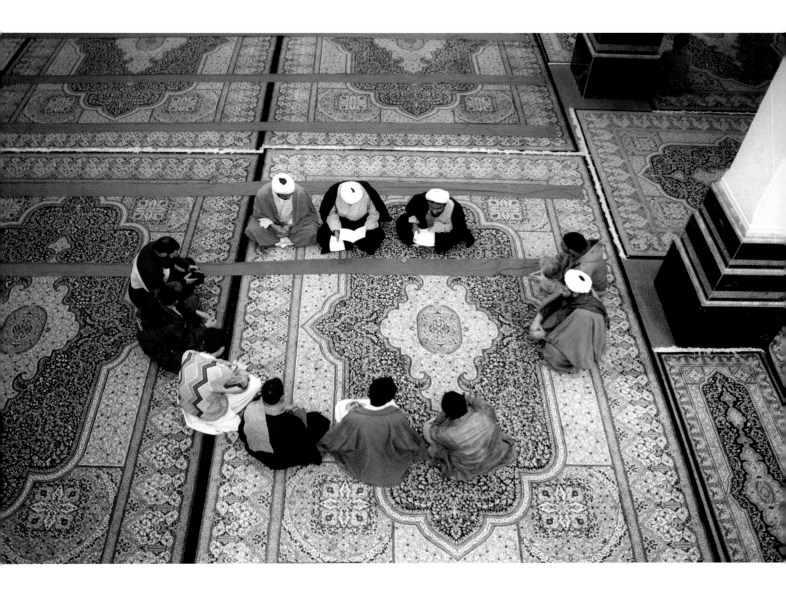

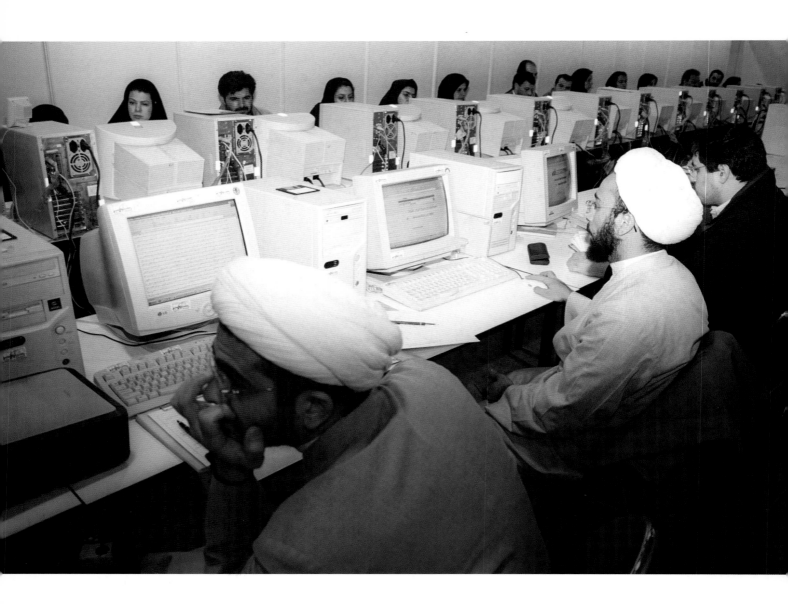

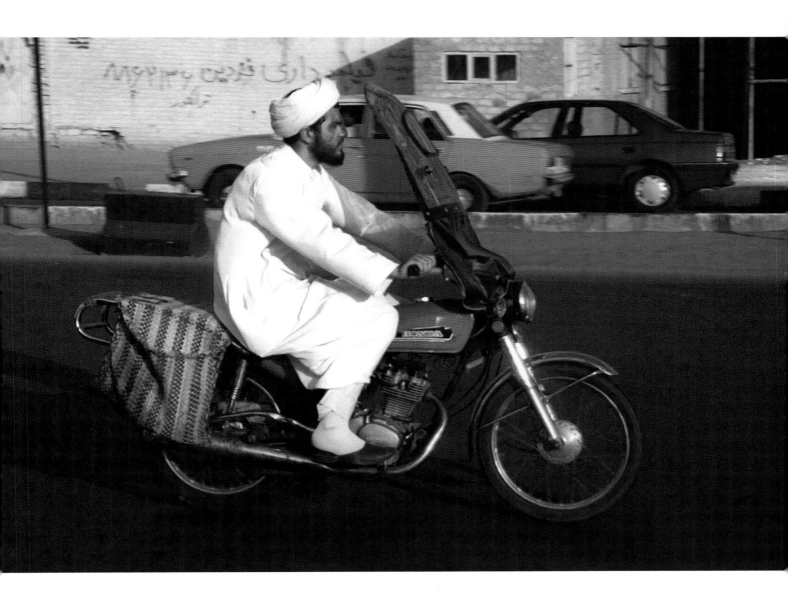

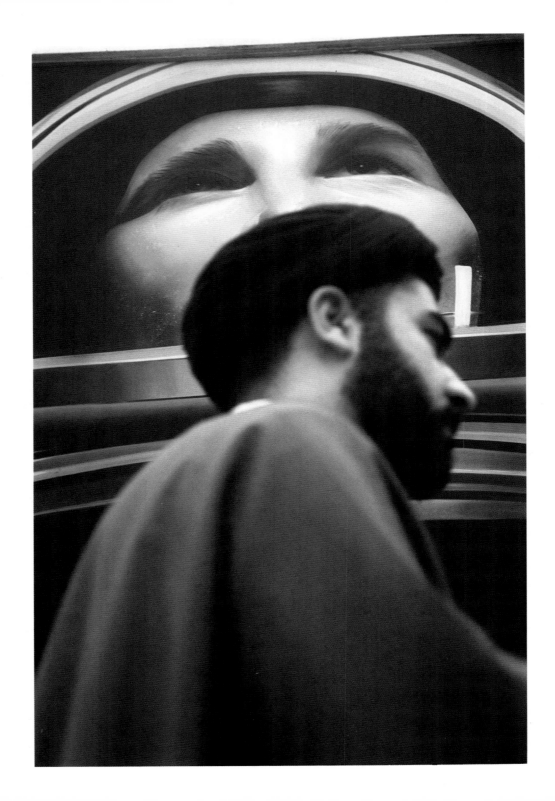

LES
FLANEUSES

Abbas Kowsari

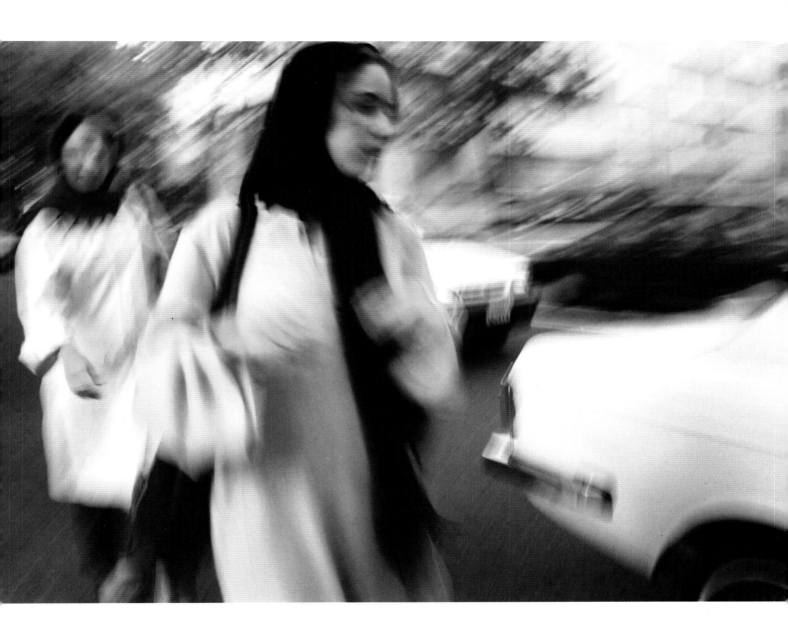

Abbas
Kowsari

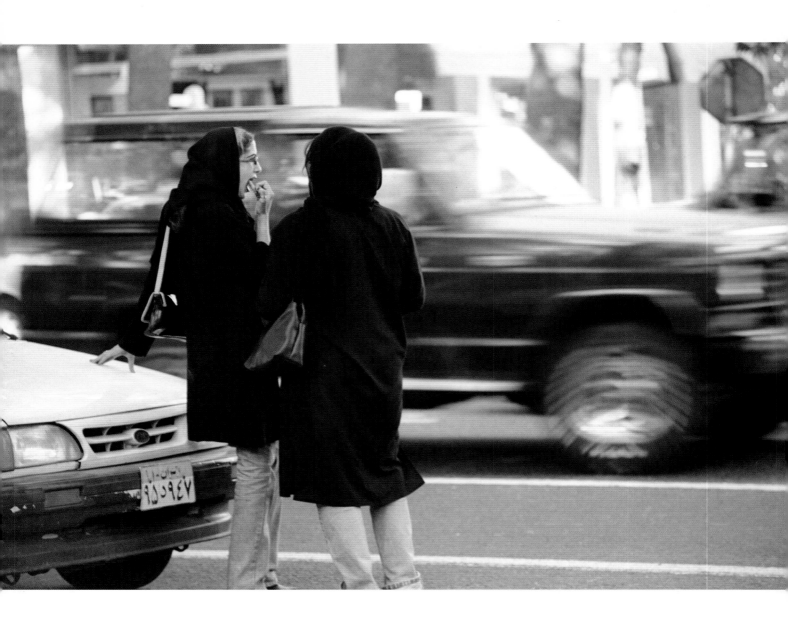

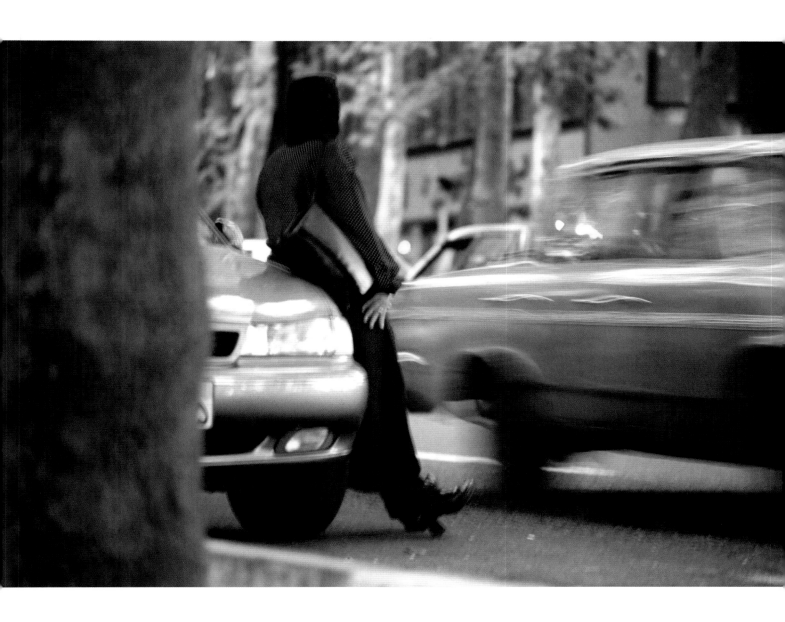

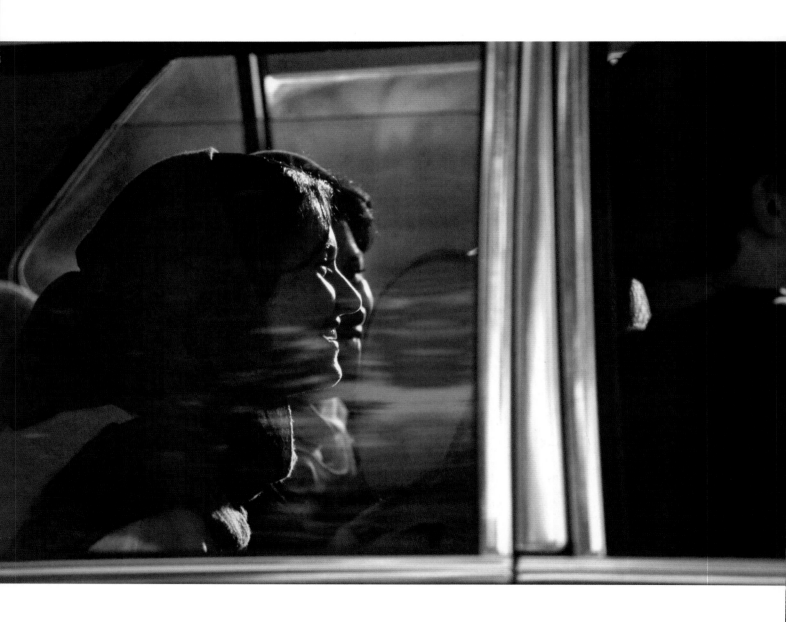

Abbas
Kowsari

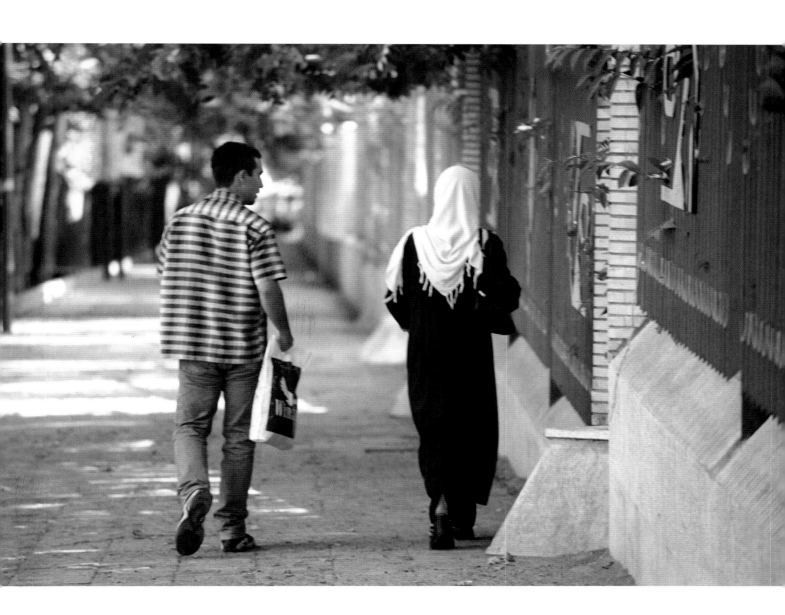

Abbas
Kowsari

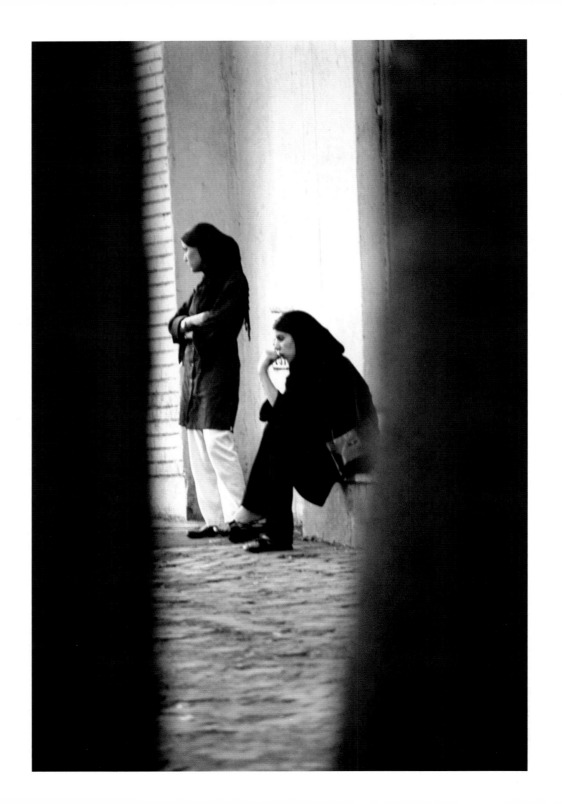

Abbas
Kowsari

LIVING MARTYR

Omid Salehi

The story of a 17 years old boy who collapsed into a coma on June 1986 in Khoramshahr city as a result of an explosion during Iran-Iraq war and has been unconcious since that time.
His parent's fight against the devil of coma and sleep .

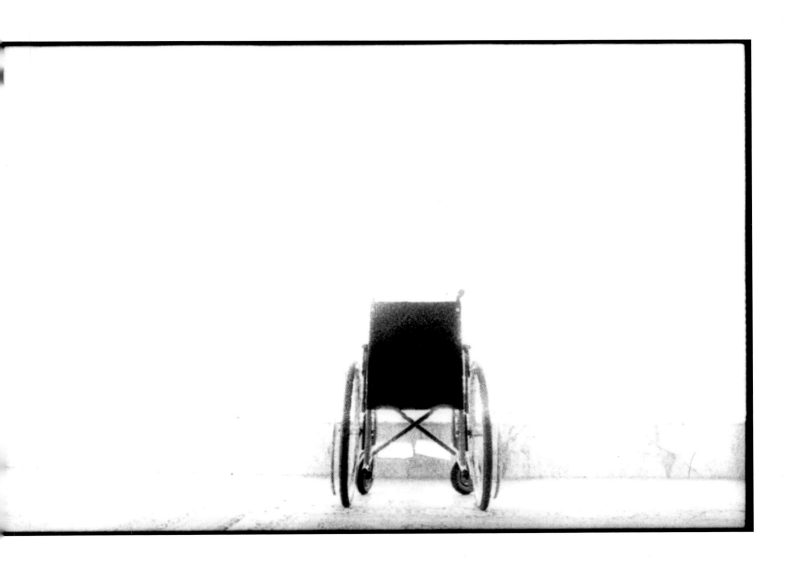

Omid
Salehi

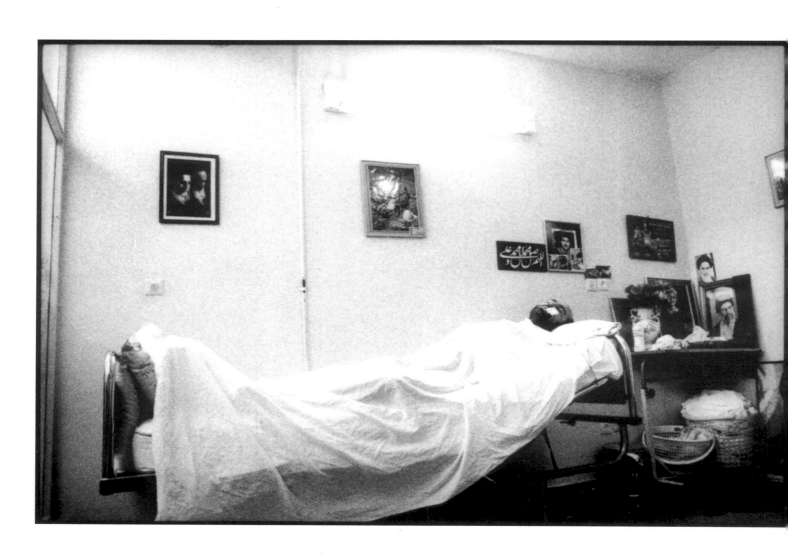

Omid
Salehi

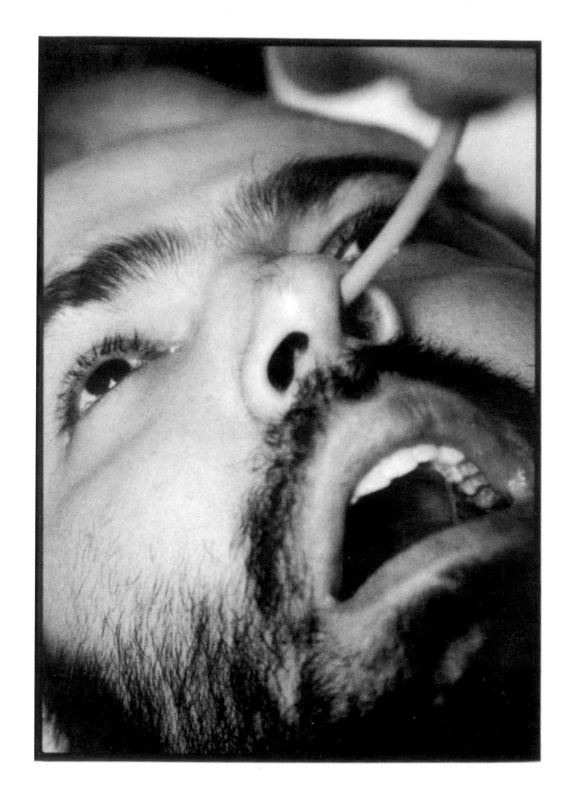

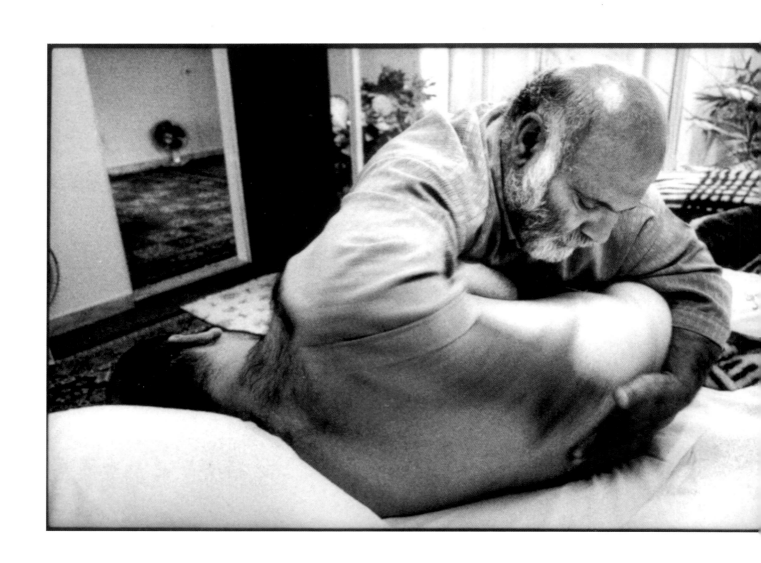

Omid
Salehi

74

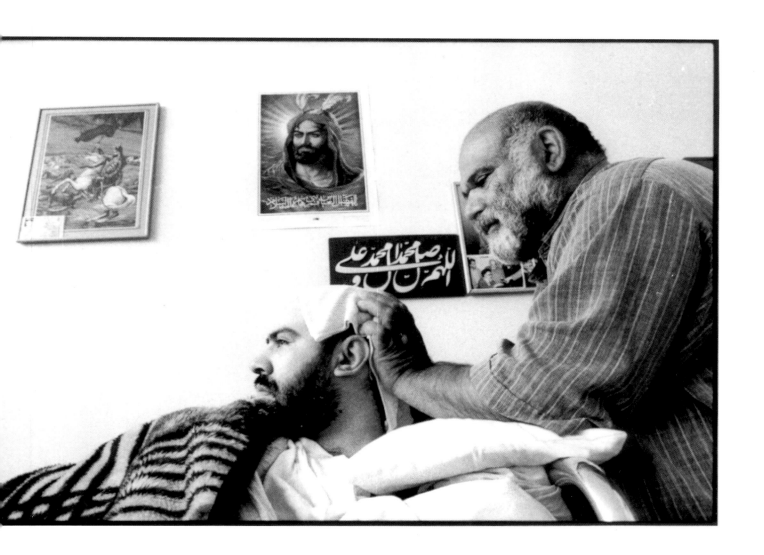

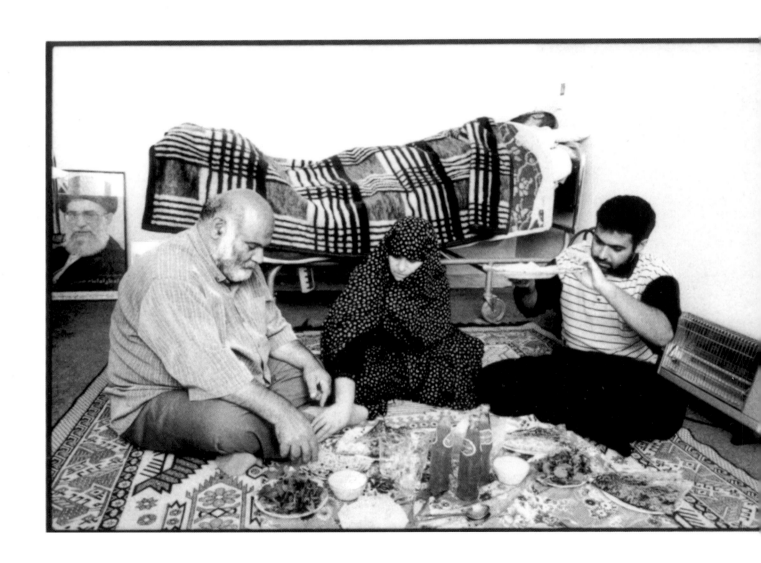

Omid
Salehi

76

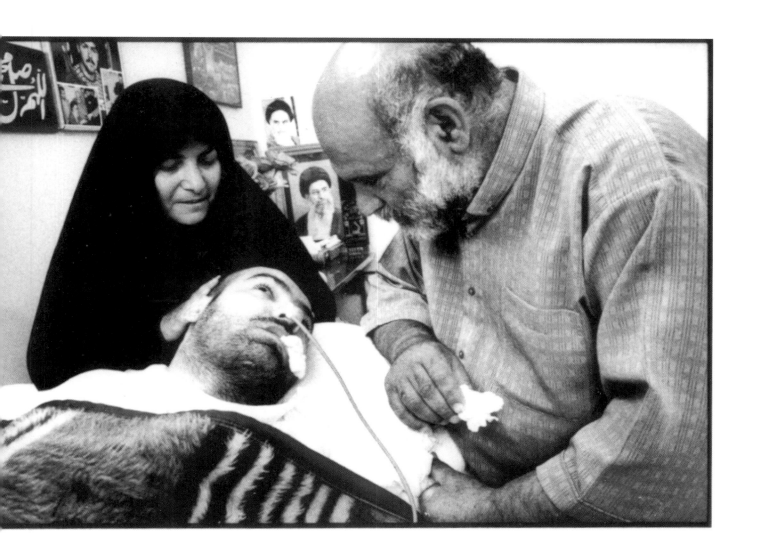

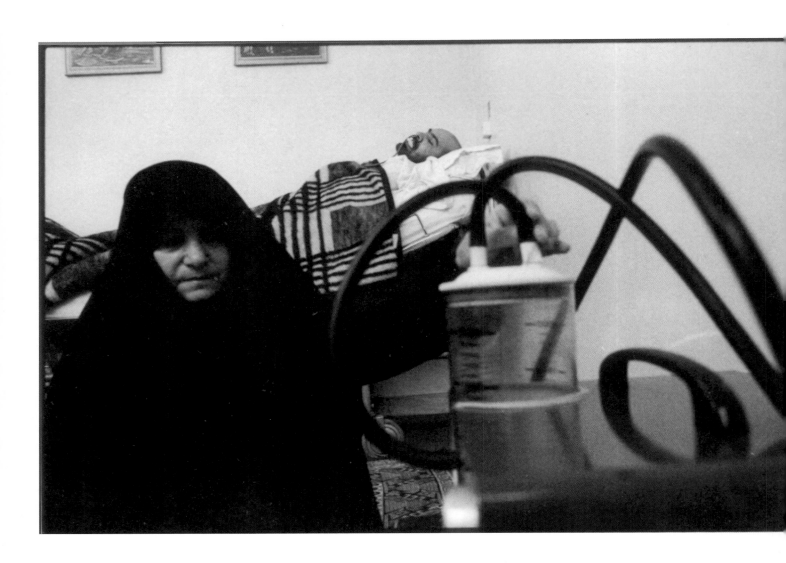

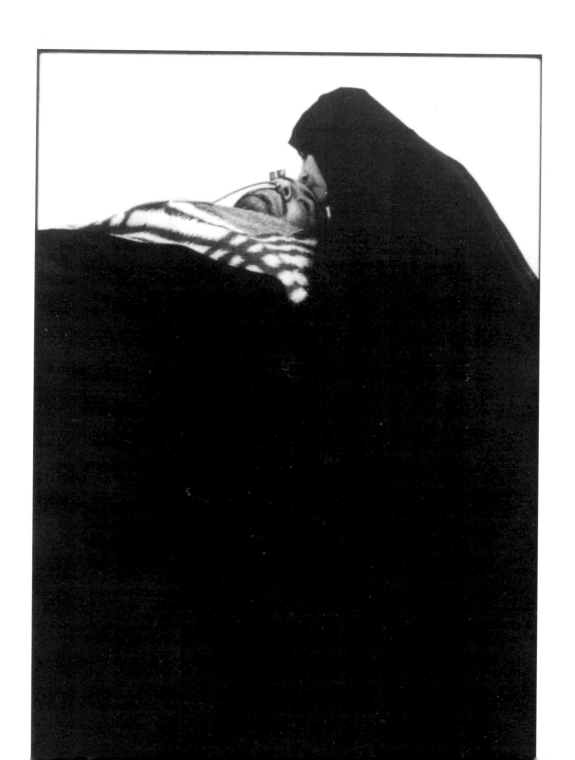

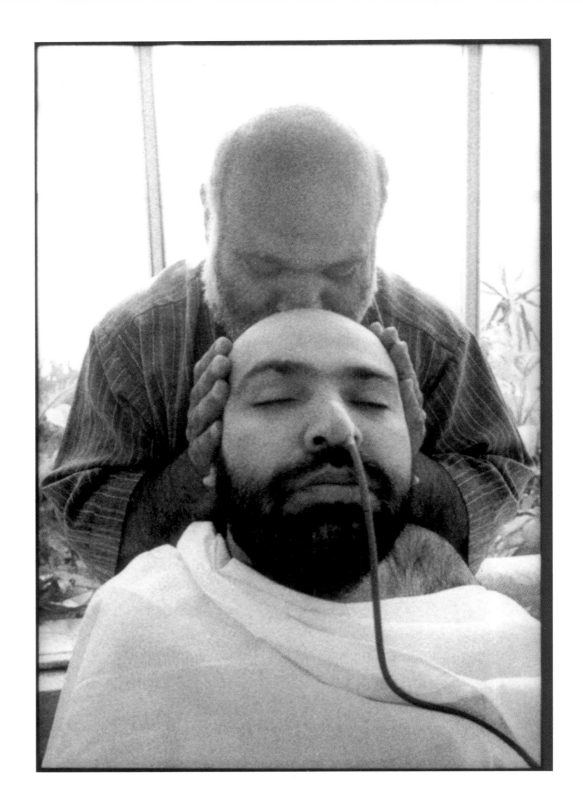

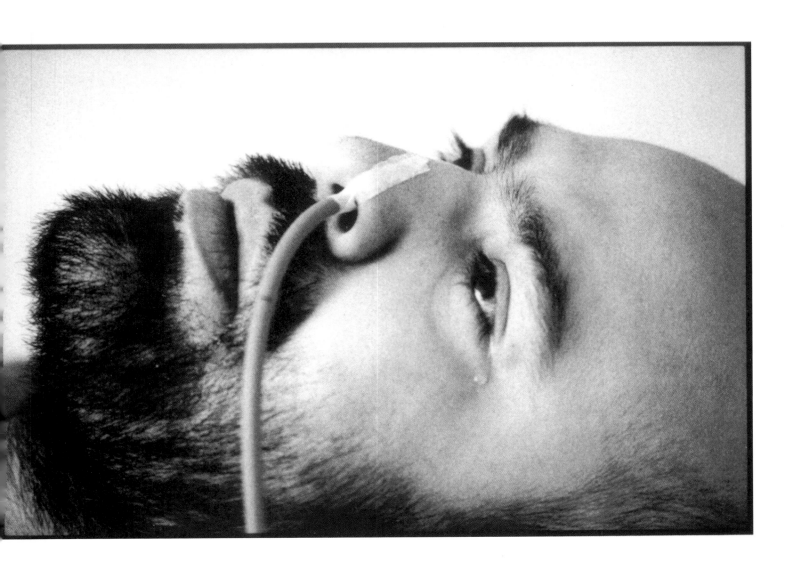

A CAFE
IN TEHRAN

Mehraneh Atashi

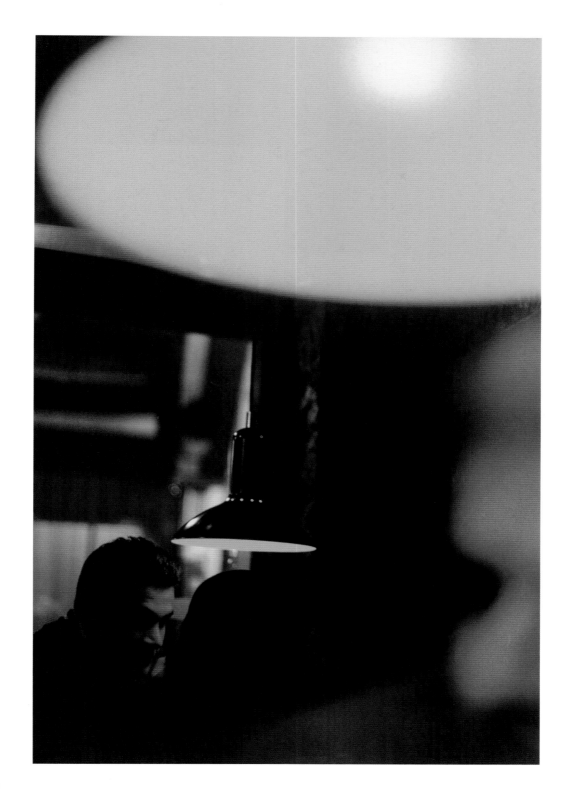

Mehraneh
Atashi

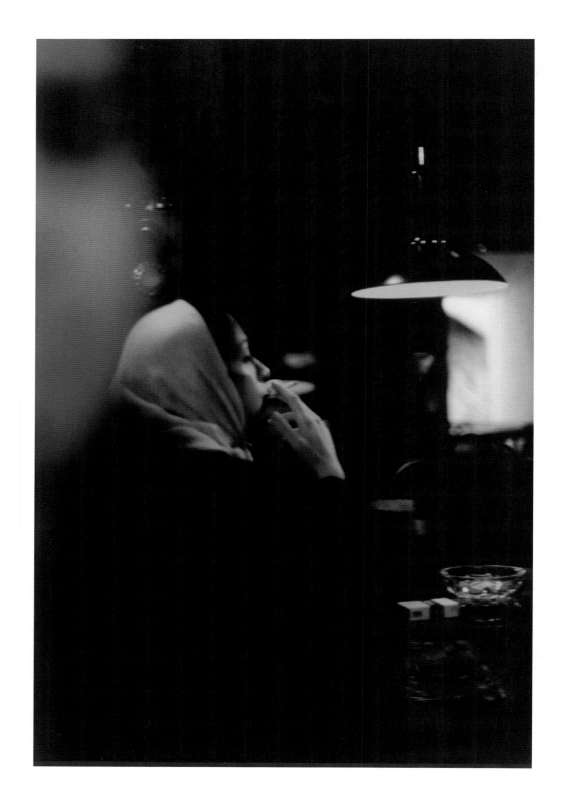

Mehraneh
Atashi

Mehraneh
Atashi

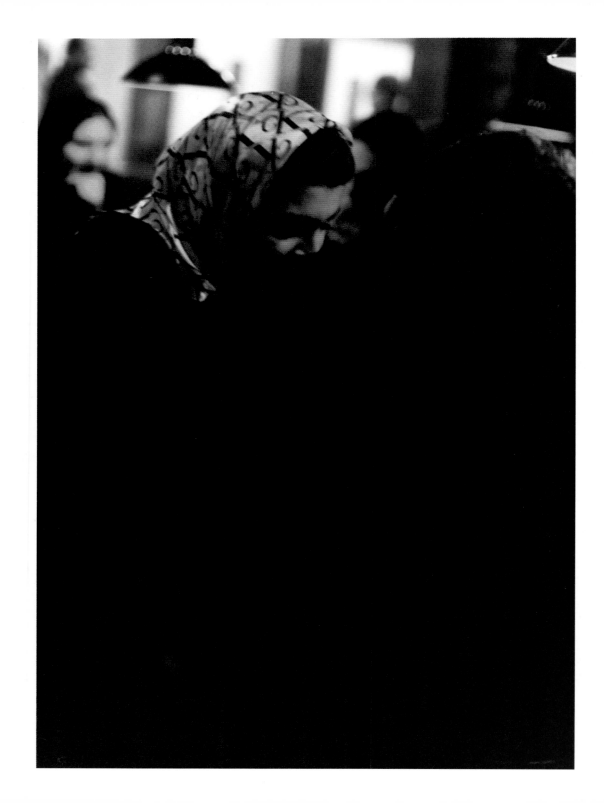

Mehraneh
Atashi

Mehraneh
Atashi

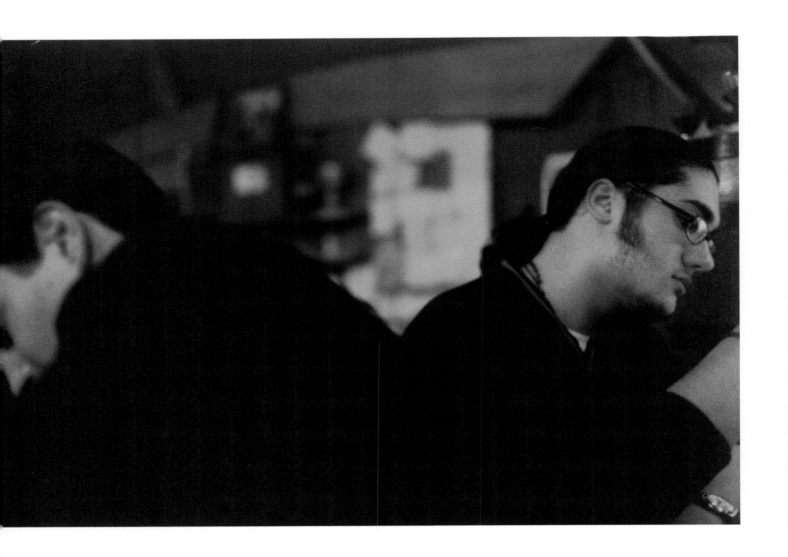

Mehraneh
Atashi

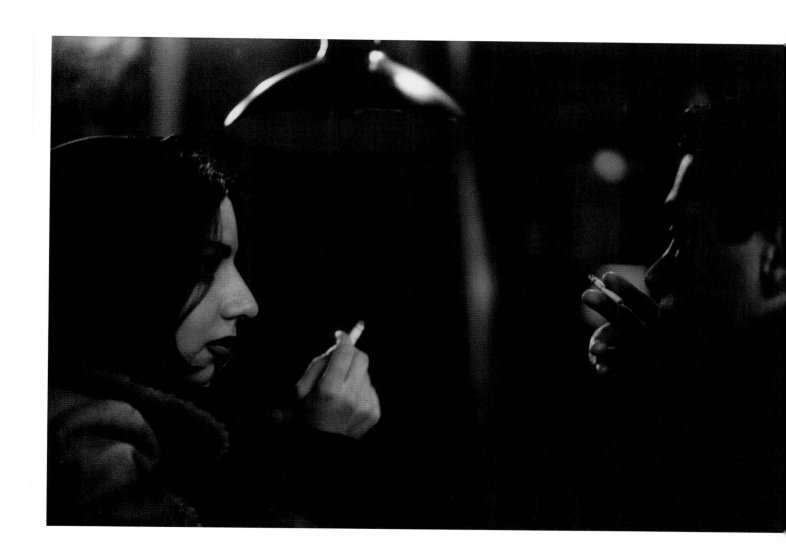

Mehraneh
Atashi

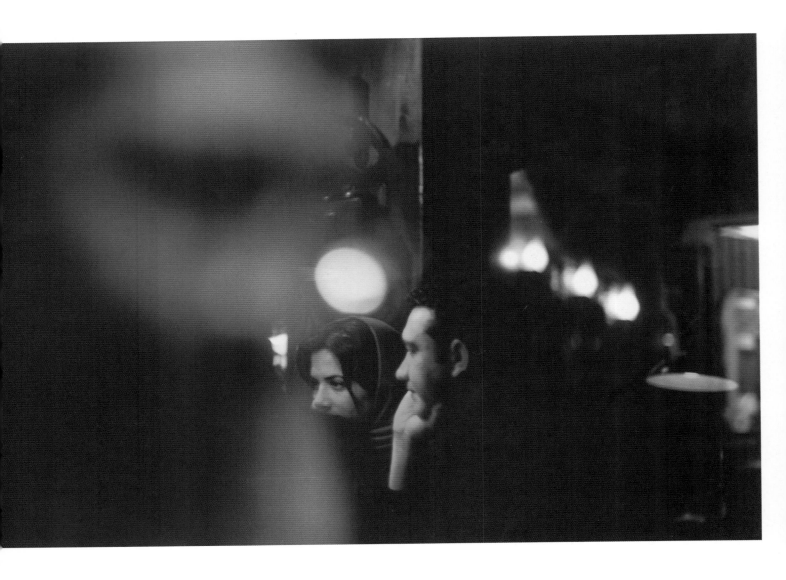

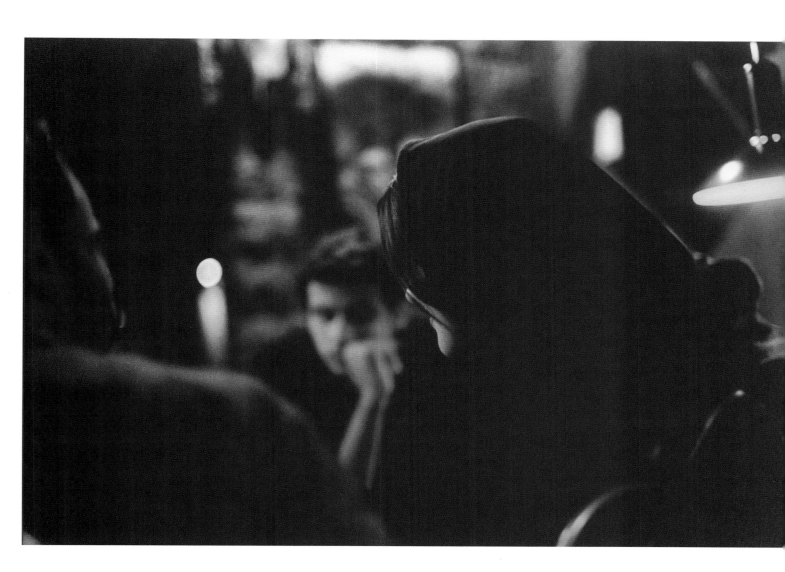

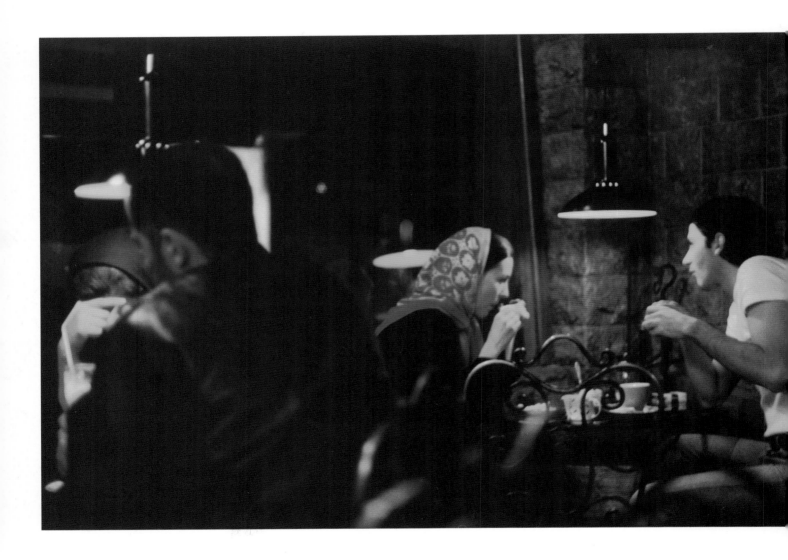

Mehraneh
Atashi

92

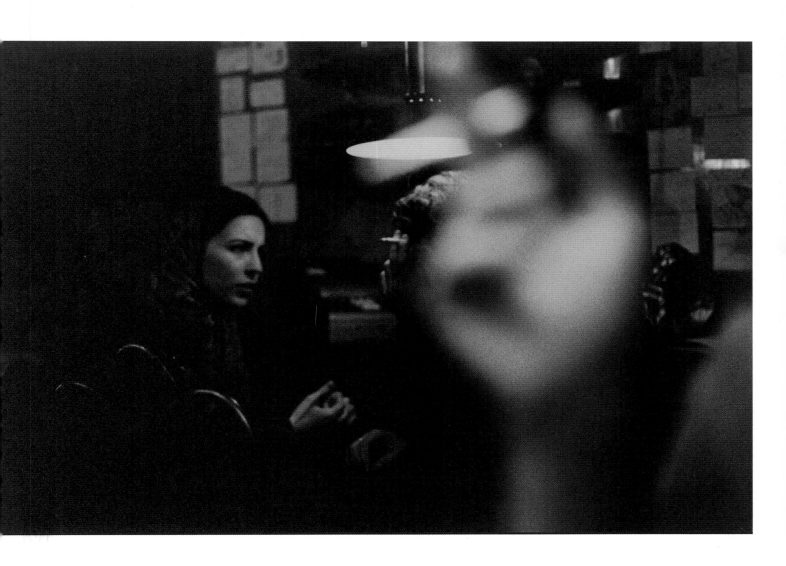

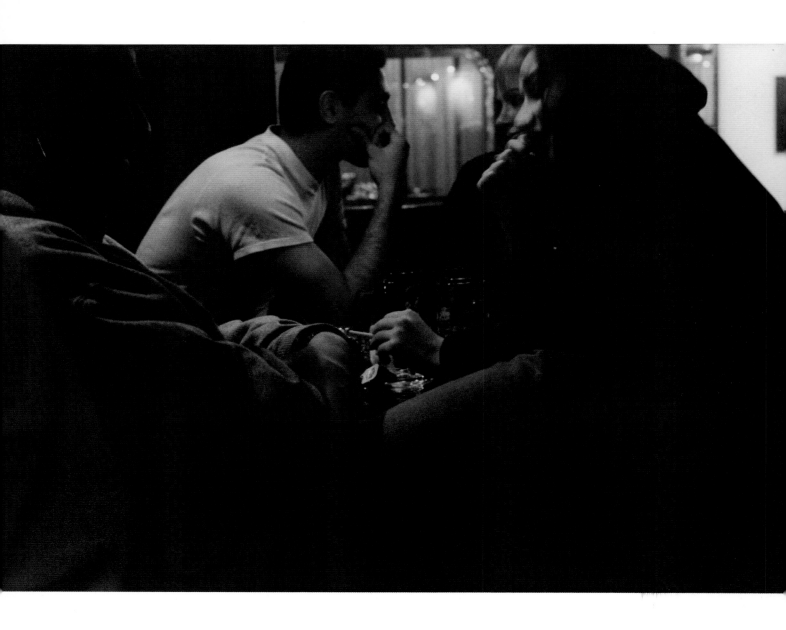

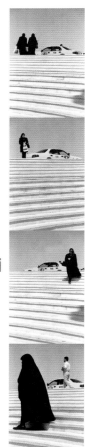

STEPS

Bahman Jalali

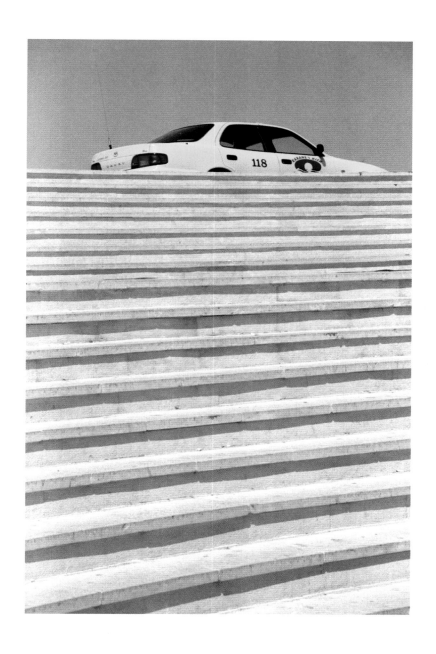

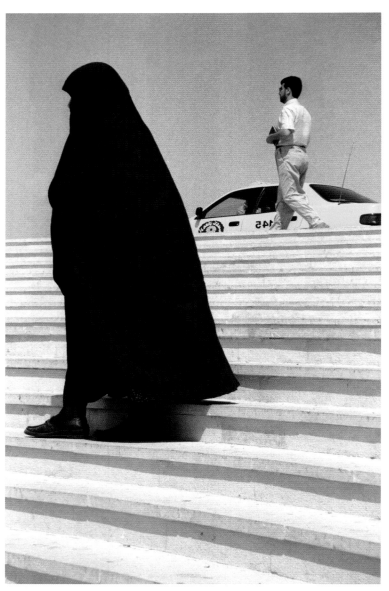
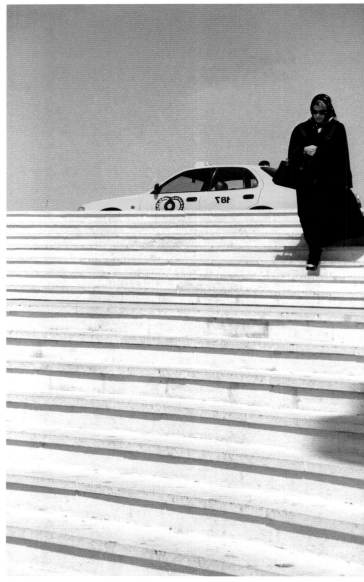

Bahman
Jalali

98

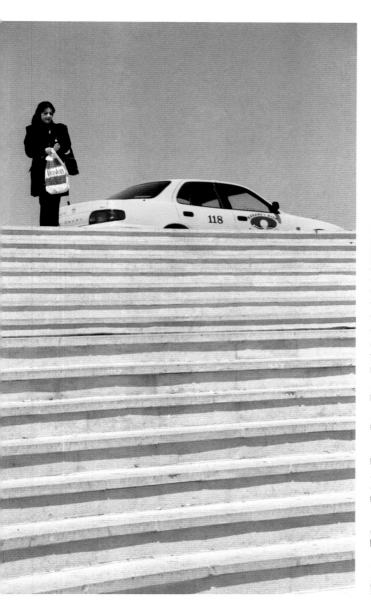
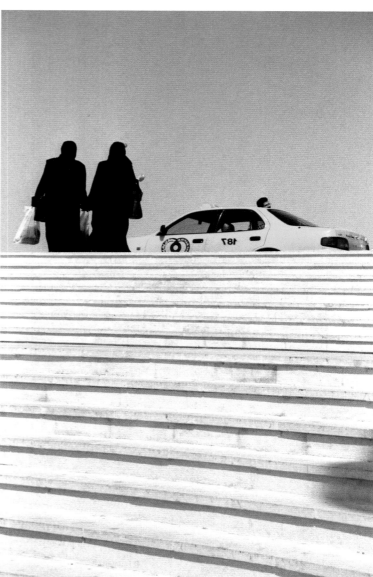

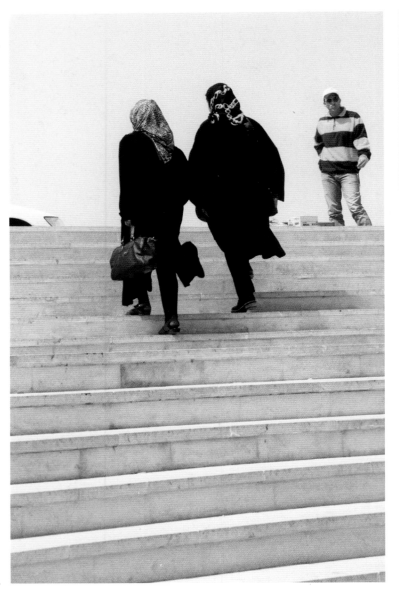
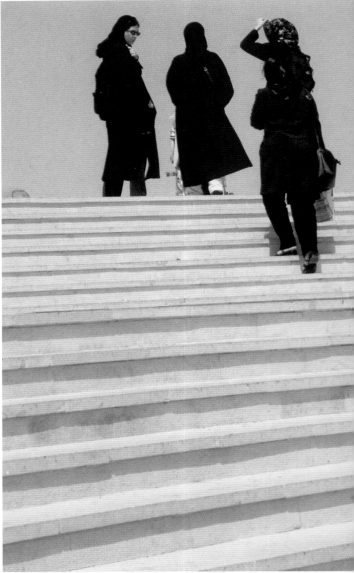

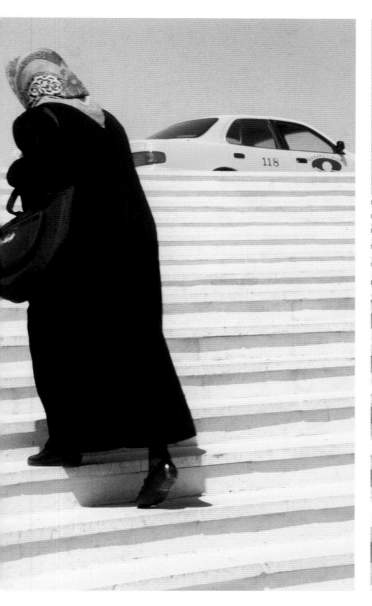
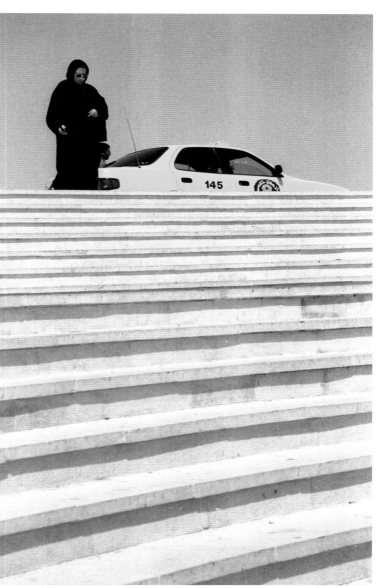

BUS TRIP

Farzaneh
Khademian

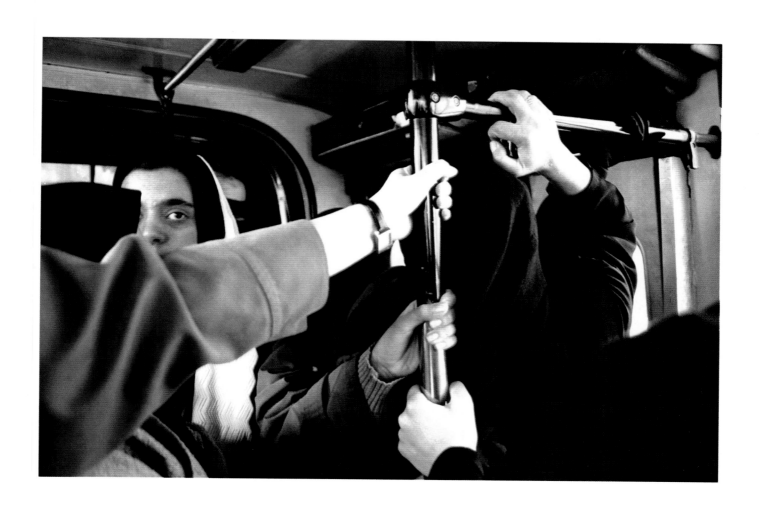

Farzaneh
Khademian

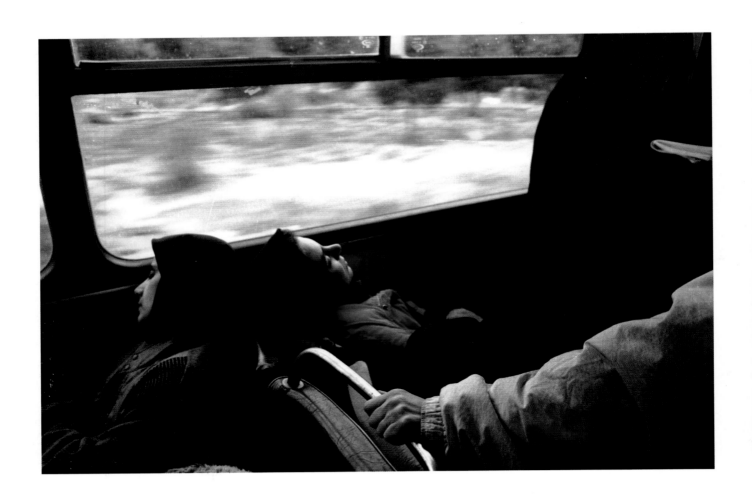

Farzaneh
Khademian

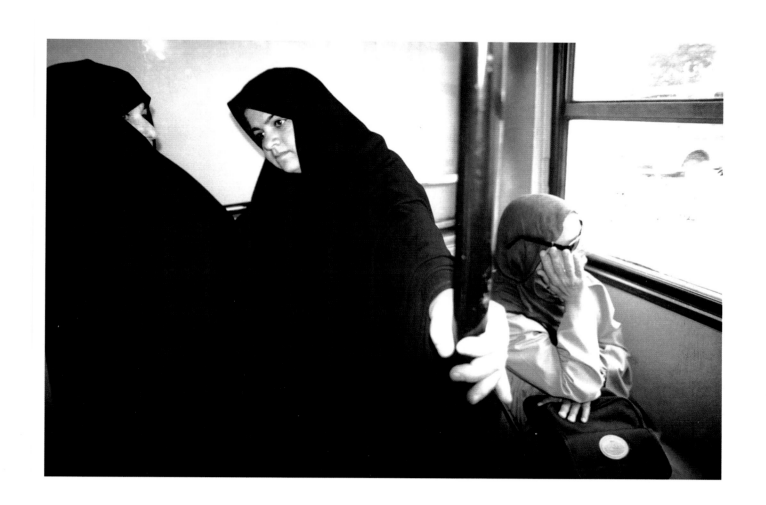

Farzaneh
Khademian

105

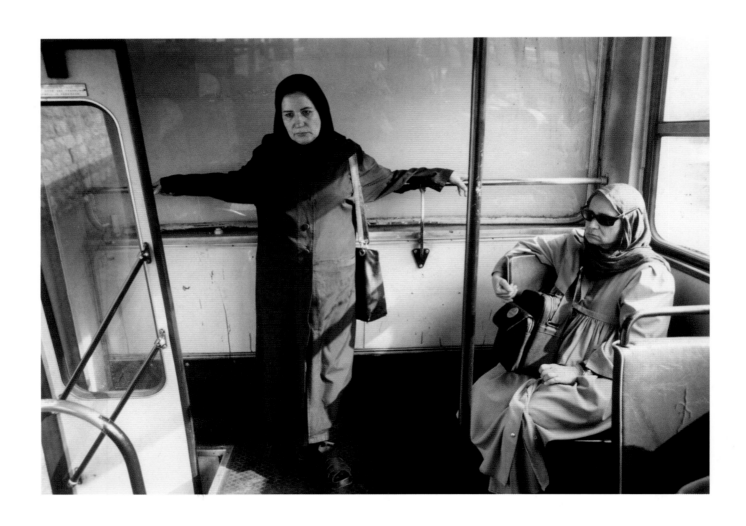

Farzaneh
Khademian

THE MALL

Yalda
Moayeri

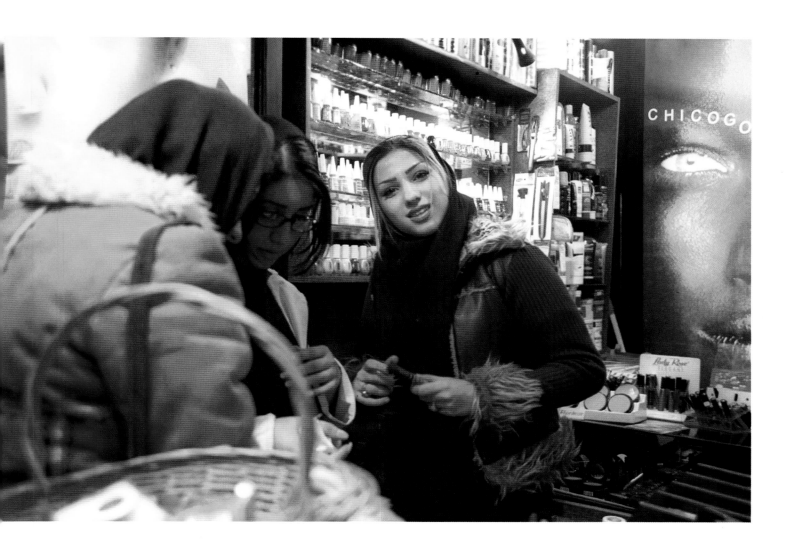

Yalda
Moayeri

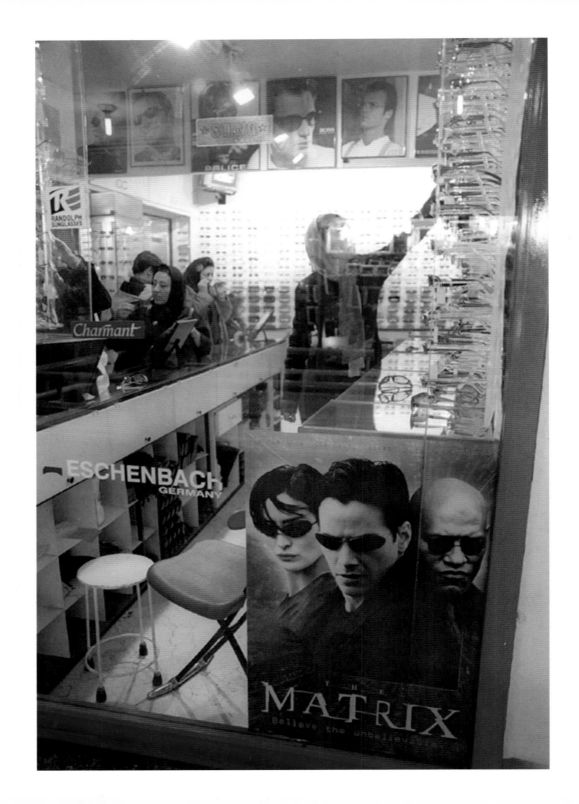

Yalda
Moayeri

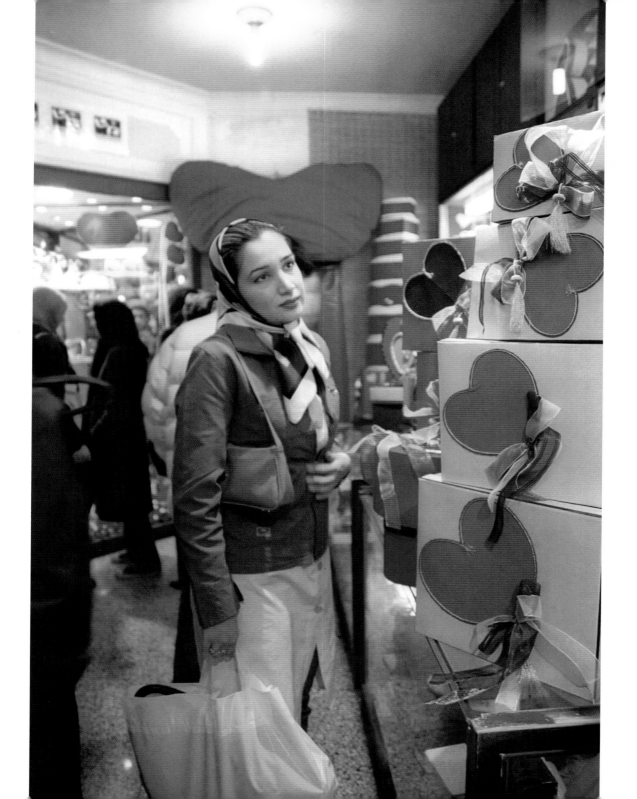

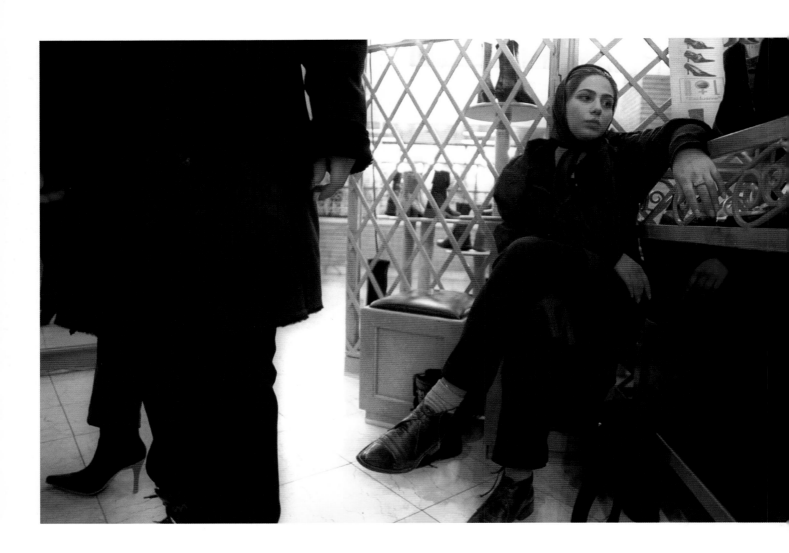

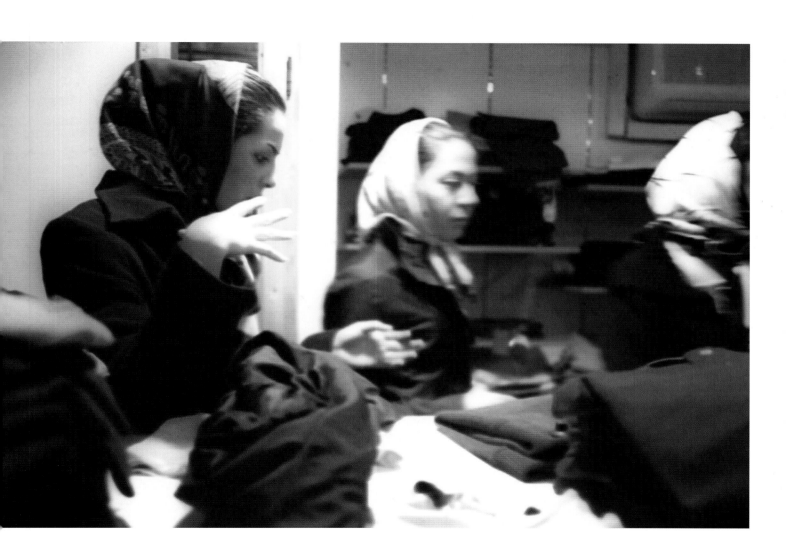

Yalda
Moayeri

113

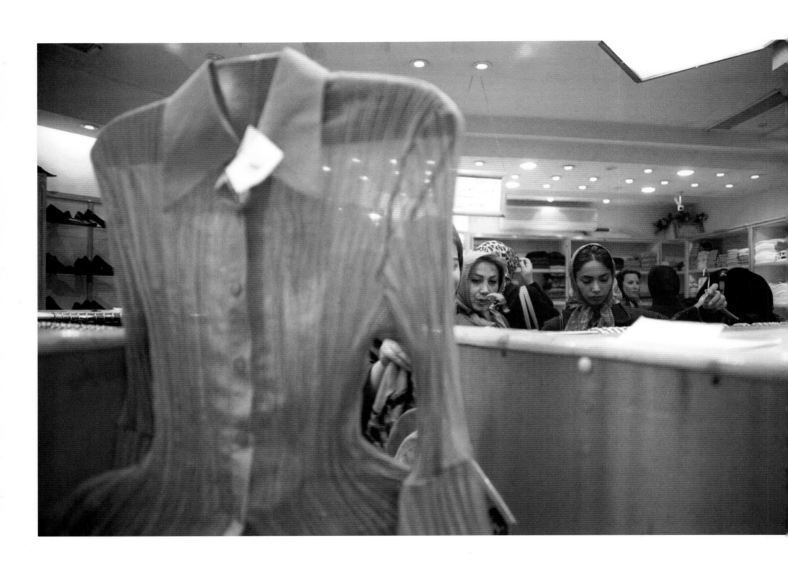

Yalda
Moayeri

WOMEN

Javad Montazeri
Omid Salehi

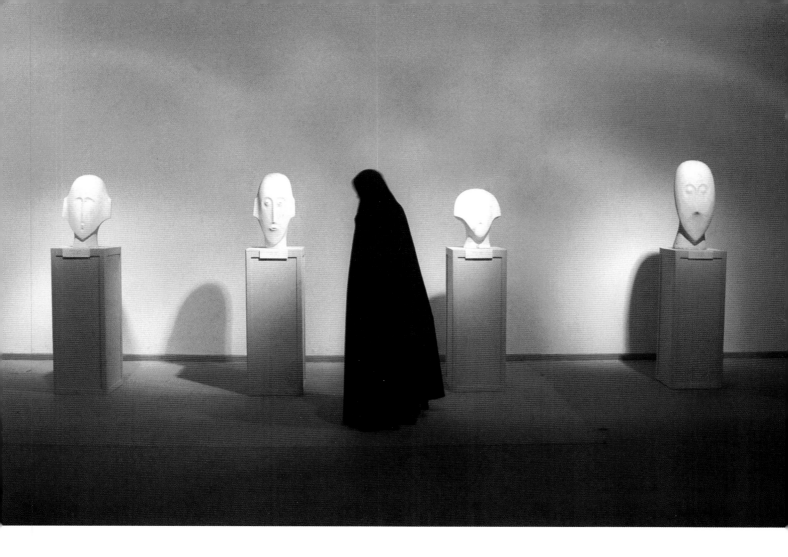

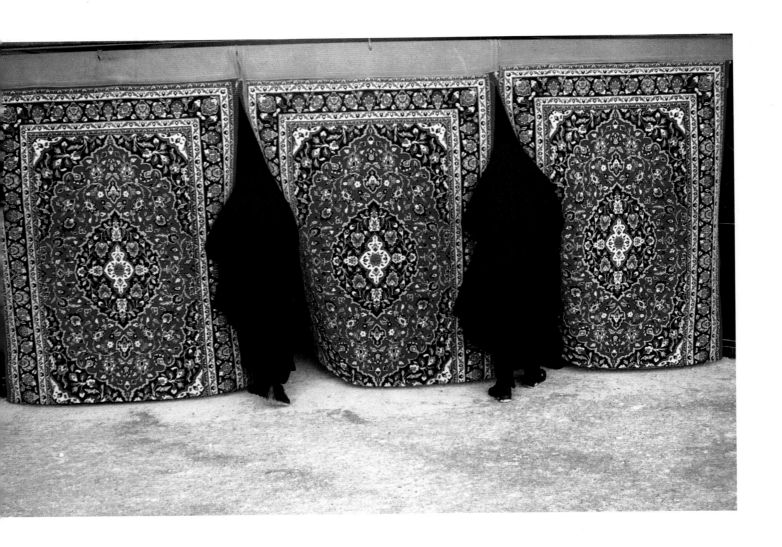

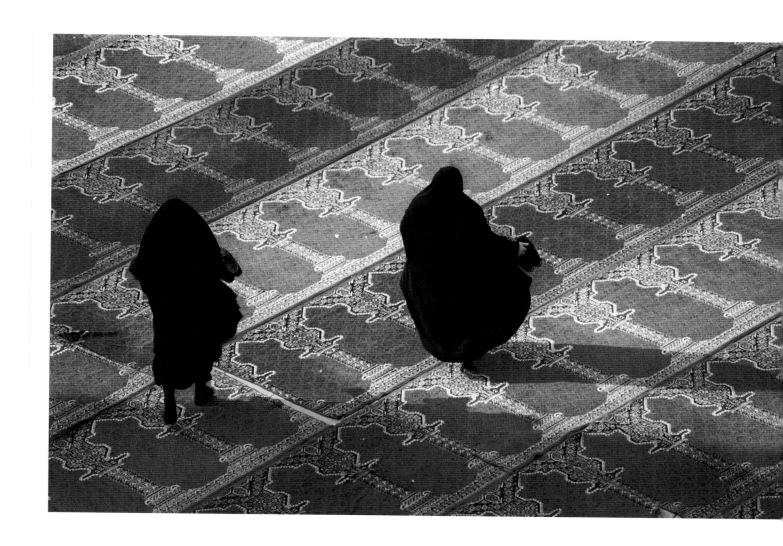

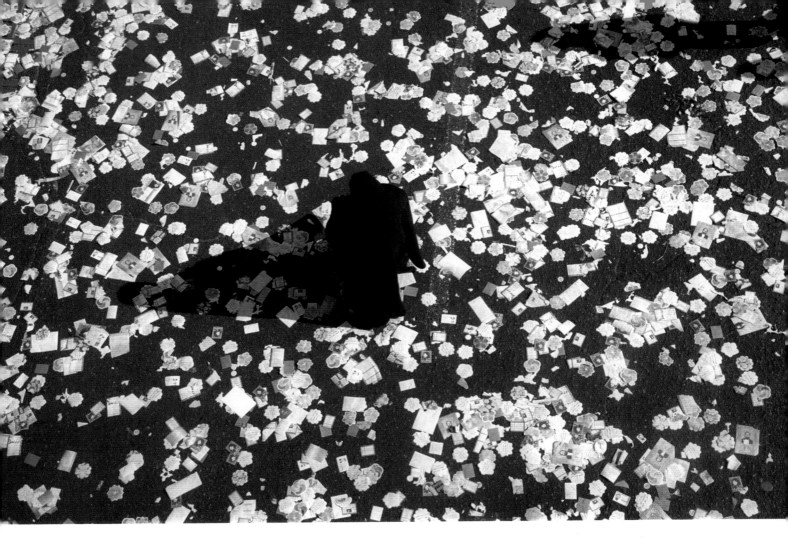

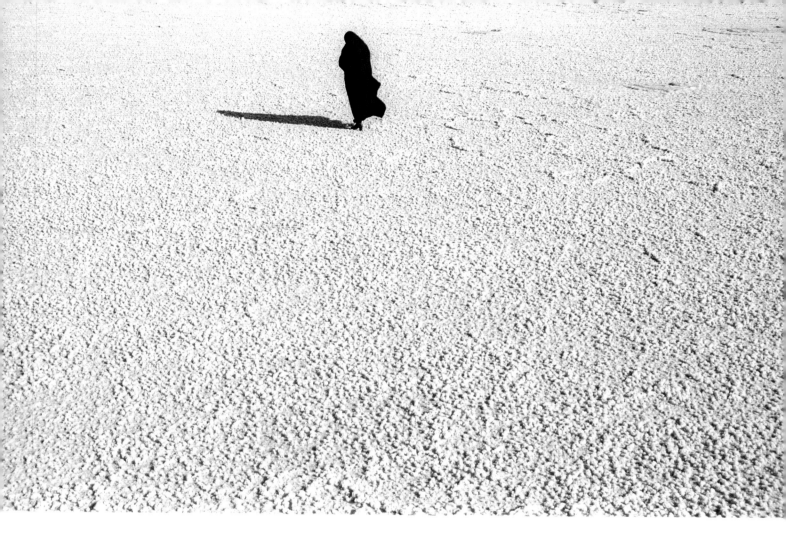

Javad
Montazeri

BIOGRAPHIES

Mehraneh Atashi

One of the youngest woman photographers active today (born in 1980), Mehraneh Atashi works for a host of major newspapers, magazines and TV programs. Her photos search out the quest of the younger generation for privacy within public surroundings, sometimes punctuating them with moments of great intimacy. She does not try to resolve the contradictions, extracting great force from the ambiguities. She is a graduate of Fine Arts Faculty of Tehran University.

Hana Darabi

One of the youngest of the photographers presented here. Born in 1981 Hana Darabi is still a student at the Department of Visual Arts Tehran University. She explores the drama in the ordinary where nothing seems to happen. Her photographs are given extra force by the use of a soft black and white.

Bahman Jalali

Bahman Jalali is the oldest and the master of the younger generation of emerging photographers. He was born in 1944 and is the author of several photography books as well as theoretical works in his field. He is one of the first to have launched photography as an art in Iran and to have made it acceptable as such to the general public. In the series presented here Jalali sat fixed at the bottom of the 'Steps', and allowed his subjects to define and compose them-selves in front of his camera, both the elements and the colors which culminate in the infinite sky.

Farzaneh Khademian

Born in 1972, Farzaneh Khademian studied photography at Azad University of Tehran. She has collaborated with a number of daily newspapers and held both individual and group shows. She is a board member of the 'Association of Iranian Photo-journalists' and has won a number of prizes over the years. She brings out the emotions as well as indifference underlying the lives of the anonymous in a modern urban society.

Arshia Kiani

Born in 1972 Arshia Kiani graduated from Iran University in Medical Studies. Between 1999 and 2003 he has worked as a photographer with both Iranian and foreign journals and magazines. The emotions and passions of 'Ashoura' have rarely been portrayed with greater force.

Abbas Kowsari

Born in 1969, Abbas Kowsari started his career as a journalist in 1994 and worked for a number of Persian language and English newspapers in Tehran. Over the years he has participated in several photo-journalistic exhibitions and won prizes, including the first prize in the 'Association of Iranian Photographer's Competition' in 1997. He has also worked with the AFP and other foreign news agencies. He captures the less obvious happenings in the world around him, and makes them captivating by his humor.

Yalda Moayeri

Daughter of a photographer, Yalda Moaieri began learning her art at the age of 16. She was born in 1981. While working for news agencies, her camera explores the modern in an Islamic society. She brings out the tensions inherent in such conditions but treats them with freedom and humor.

Javad Montazeri

Born in 1968, Javad Montazeri studied photography at Azad University of Tehran and has worked extensively for local and international news agencies including Reuters. He is recipient of a number of prizes in photography. His camera takes the viewers into the sanctuaries of Shi'ite learning bringing out the unexpected in the lives of 'talibahs' (students of religious studies).

Omid Salehi

Born in 1972, Omid Salehi studied Graphic Arts in Iran. After graduation he worked for various Tehran dailies as well as a project for Iranian TV. He has won a number of first prizes for his photography. He searches the social and the extraordinary in the lives of the people in Iran. In the series presented here, he has found, says, the focus of all his efforts so far where the camera explores a tragic human condition within four walls of a house, portraying the pains as well as the dignity of a lower income family in Iran.

Hamideh Zolfaghari

Born in 1959, Hamideh Zolfaghari studied photography at San Jose University and other institutions in the USA. She has participated in a number of group exhibitions as well as solo shows in Tehran and the USA and won the first prize at the 1989 'Third Annual Photography Exhibition of Iran'. In 1994, she co-authored with Nasrollah Kasraian the photo book 'Tehran'. She has also worked as a photographer for UNICEF. In her work she documents the rituals of Persian life in sketches of 'Ashoura' as well as others such as village wedding ceremonies in a society in transition.